DARKROOM TECHNIQUES

Volume 1
The Darkroom
Film Development
Basic Photo-Chemistry

by Andreas Feininger

With 107 Plates

THAMES AND HUDSON · LONDON

Other books published by ANDREAS FEININGER

Table of Contents

I. Preliminaries

WHY I WROTE THIS BOOK

Not so long ago, a friend of mine, who had become interested in photography and wanted to learn how to develop his own black-and-white films and print his own negatives, asked me for the title of an inexpensive book suitable to introduce him to the magic and the mysteries of the darkroom. Unable to recall such a guide offhand, I borrowed about a dozen likely candidates by different authors—books on darkroom technique written especially for the beginner. I went through each of these books carefully and critically and in the end concluded that, in the entire stack, there was not a single book that I could recommend wholeheartedly.

Although each of these books had some good features, I found that, at least in my opinion, every single one also had some major faults. Some authors were much too thorough, loading their books with information that doubtless is of interest to specialists (like optical or chemical engineers), but useless and even confusing as far as the practicing photographer and particularly the beginner is concerned. Other writers made the opposite mistake, benevolently talking down to their readers as if they had the mentality of six-year-old children. Quite a few books were disorganized, redundant, or verbose, creating the impression that darkroom work is an extremely complicated matter whereas, actually, developing a roll of film or making a print requires less skill than making a good omelette. Many books were inadequately illustrated. Others were too gimmicky or too old-fashioned, devoting excessive amounts of space to obsolescent techniques like toning, flashing, hand-coloring photographs, or spraying clouds on "bald" skies, indicating that, in spite of alleged revisions, they had not been updated for many years. And virtually all of these guides were too specific insofar as they were loaded with the kind of information that sooner or later becomes obsolete, like step-by-step instructions for developing specific types of film, developer formulas "tailored" to fulfill demands no longer pertinent, or advice in regard to the operation of photographic equipment

long since discontinued. In my opinion, this kind of *short-lived* information has no place in a book (1) because it is easily outdated and then becomes not only useless, but actually misleading, and (2) because it is available *free* since every new camera or other piece of photographic equipment, every roll or package of film, every developer or other photographic solution, every processing kit, is accompanied by the manufacturer's instructions for use—data which always are authoritative and up to date. Misusing this kind of free information by including it in a book to make it appear more attractive and complete is, in my opinion, a form of "cheating" on the part of the author.

It was thus my disappointment in all the books on black-and-white dark-room techniques available to me that prompted me to compile the present guide. Learning from what I considered the mistakes of other authors (profitably, I hope), I set myself strict guidelines for the selection and organization of the material to be included in my book, admonishing myself to keep it simple, yet complete; to keep the illustrations meaningful; and to treat the reader as an intelligent, motivated adult without previous photographic experience.

Practical considerations prompted me to divide *Darkroom Techniques* into two parts:

Volume I is devoted to the **darkroom** and to **film development;**

Volume II is concerned with **printing** and **enlarging.**

Both volumes deal exclusively with black-and-white photography (readers interested in color photography are referred to my books *Basic Color Photography,* Amphoto; Thames & Hudson; and *The Color Photo Book,* Prentice-Hall, Englewood Cliffs, N. J.). The result, I hope, is a thoroughly practical introduction to the various aspects of developing, printing and enlarging black-and-white films, based upon my 35 years of experience as a printmaker and my 20 years of experience as a staff photographer for *Life.* Not surprisingly, it is a very *personal* book, a book in which I included *everything* I found *necessary* for successfully developing films and making prints but deliberately left out what I consider frills. Likewise, I avoided including any kind of information liable to become obsolete during the life of this book, preferring instead, as already mentioned, to refer the interested reader to the always authoritative information provided by manufacturers for the use of their products. This, of course, eliminates any need on the part of the reader to worry whether the instructions he just read are still valid.

WHY A PHOTOGRAPHER NEEDS A DARKROOM

Having a darkroom at your disposal gives you advantages over your less fortunate colleagues which amount to more than merely the chance to develop your own films and print your own negatives. Access to a darkroom pays off in the form of the following bonuses:

Quality. You get *better results* than if you were to give your exposed film to a store for developing and printing because, in that case, it would be forwarded to a commercial photofinisher who uses *automatic* machinery set for processing *average* snapshots taken by *average* amateurs of *average* subjects in *average* light. Should your pictures fall into this category, you still would get only average prints in return, whereas if you had made them yourself, they might have been excellent. And if your pictures are *not* average but require special consideration, the result can be catastrophic.

Control. For economic reasons, photofinishers develop large numbers of rolls simultaneously in large tanks and print negatives on computerized printers programmed to make the best even of under- and overexposed negatives by automatically compensating for differences in density and gradation. Consequently, pictures taken in the pearly gray of rain or fog come out too contrasty; backlighted subjects and silhouettes appear too flat; views taken at dawn will be printed too light and brightly lit scenes too dark. But if you do your own processing, you retain complete *control* over your work and can achieve precisely the effect you envisioned when you made the shot.

Experimentation. Since you can print the same negative as many times as you wish in your own darkroom, each print different from all the others in contrast, lightness or darkness, manner of cropping, proportions, size, and so on, you can experiment to your heart's desire. You can really go to work on a promising negative, explore it until you have exhausted its potential, and extract from it the best possible print. There is a certain amount of truth in the saying that a *photograph* is made with a *camera*, but a *picture* is made in the darkroom.

Learning. Reading about photography and studying the work of other photographers is undoubtedly an important phase of the learning process, but it is useless unless complemented and amplified by practical experience. If you want to become an accomplished photographer, there is simply no substitute for actually making pictures. But unless you yourself have ex-

plored the possibilities of developing and printing, you will never be able to probe fully the potential of the photographic medium. Access to a darkroom with its opportunity for unlimited experimentation amounts therefore to an invaluable opportunity for learning. In this sense, every mistake you make is a blessing in disguise, a priceless chance for learning something new. And once made and understood, you never have to make the same mistake again.

Stimulation. Since time immemorial, prerequisites for meditation and exploration of the inner self have been isolation, solitude, and quiet. For a photographer, a retreat to the darkroom is the modern equivalent of the ancient custom of retreating into the desert or to a mountain top. For there is something magic about the atmosphere of a darkroom—a feeling of peace and security, of escape from the crushing pressure of daily life, that is further heightened by the near-darkness of a room illuminated only by pools of reddish-yellow light. Isolated from all outside influences, a photographer is free to concentrate on the task of creating pictures. Exploring his negatives in every respect by printing them in different ways, he has a chance of becoming not only an expert printmaker, but also a better photographer by discovering in the finished print the shortcomings of the negative. I don't mean here possible technical defects, but conceptual and pictorial deficiencies, faults inherent in the angle of view at which the subject was seen, unsatisfactory perspective resulting in "distortion," a wrong type of light, a wishy-washy composition. To the creative mind, darkroom work provides an endless source of the kind of *stimulation* indispensable to artistic growth.

Speed. Photographers processing their own films don't have to be in suspense for days before they can see the result of their efforts. Although normally a minor advantage, occasionally this extra speed can make the difference between success and failure as, for example, in cases in which it is still possible to reshoot an unsatisfactory picture if the result is known within hours, but impossible if one has to wait for days.

Monetary savings. In the long run, despite the initial investment and the running cost, processing your own films is considerably cheaper than letting a commercial photofinisher do the work.

To get an idea of the freedom with which an experienced printer can create, study the pictures on the following eight pages, all of which derived from the same negative. Then imagine each of them in still other versions—lighter or darker, more or less contrast—and you will see why any ambitious photographer needs his own darkroom.

10

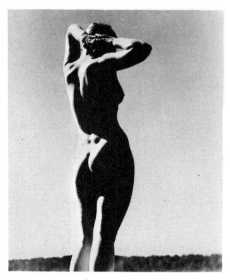
A commercially made print.

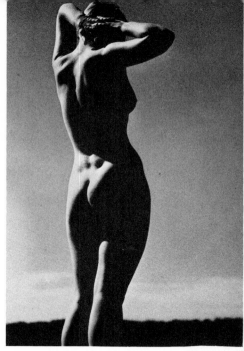
A print made by the author.

What's in a negative?

Probably more than you think, and almost certainly more than what comes out in the prints which you get from your local photo store. Because there is a world of difference between a print made with care and understanding by a photographer who strives to capture the essence of a subject as he experienced it, and a print made mechanically by a computer-controlled machine. To give the reader an idea of the immense scope in regard to variety of form of graphic expression which can be his, I show on this and the following seven pages 19 different versions of one subject, *all of which were made from the same negative.*

This collection of pictures represents a deliberate exercise in creative print control, the point of which is to explore systematically the more important ones of the various techniques by means of which the graphic effect of a photograph can be controlled. In addition to the techniques illustrated here, still others exist, like, for example, perspective control, creative distortion, high-key and low-key printing, softening (diffusing) and zooming during enlarging, and so on; these will be discussed in Volume II. Although not every version shown here may be successful or appeal to everyone, each can teach the student photographer something that may prove useful in the course of his future work.

The potential of cropping

Lighter or darker print, contrast high or low

A variety of control processes is at the command of the photographer who combines imagination with photo-technical aptitude. Three of these techniques are illustrated on this spread: cropping, lightness control, contrast control. Each can be used either alone or in combination with one or both of the others for maximum control of the graphic effect of the print.

The photo-technical problems and considerations involved in these techniques will be discussed later. What is important at this point is that the student photographer realizes *that he has many choices:* He can change the size as well as the proportions of his print relative to the negative; switch from vertical to horizontal view and vice versa; convert a square negative to a rectangular print; give his photographs a lighter or darker overall tone; and increase, maintain, or decrease the contrast range of the subject in the rendition. Which of these means a photographer chooses depends on the nature of the subject, the manner in which it affects him, the subject qualities which he wishes to stress, and the purpose of the picture.

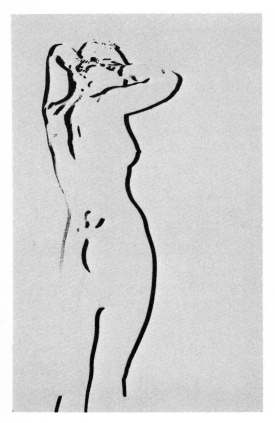 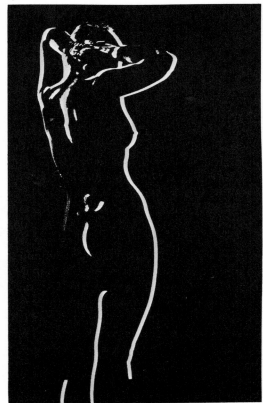

The "graphic" control processes . . .

. . . *bas-relief, solarization, reticulation,* and their combinations, offer the imaginatively gifted photographer virtually unlimited opportunities for creative expression. Illustrated here are four variations of the bas-relief process, instructions for which are given in Volume II.

The graphic control processes, which enable a photographer to produce semi-abstract

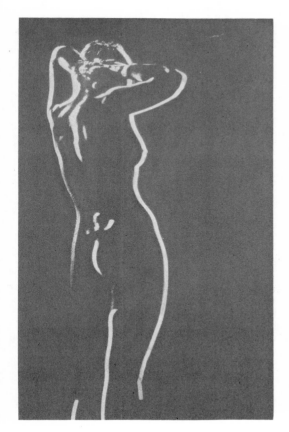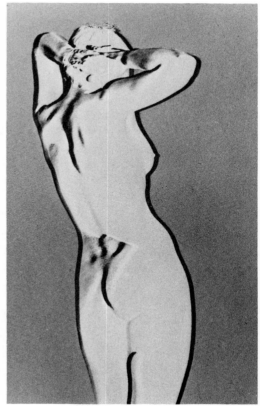

renditions from ordinary negatives, will give particularly good results in cases in which it is desirable to symbolize in picture form intangible subject qualities rather than to create naturalistic impressions. In this particular case—since any nude is basically a *symbol* of femininity, beauty, gracefulness of outline and form—a semi-abstract, "depersonalizing" form of rendition is particularly likely to bring out such characteristics. A "realistic" treatment, unless executed with great feeling and sensitivity, easily makes pictures of a nude look like nudist camp advertisements, medical textbook illustrations, or pornography.

15

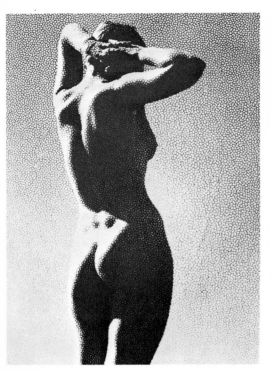

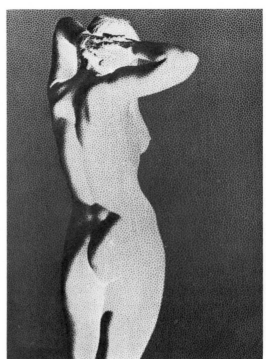

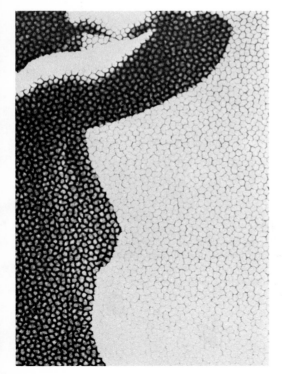

Controlled reticulation . . .

. . . unifies the elements of a photograph in the manner of a texture screen. Like a texture screen, it is used most effectively in order to obliterate deliberately unwanted detail in the rendition. But unlike a texture screen, which mechanically imposes an essentially alien pattern upon a photograph, the grain of reticulation evolves organically out of the tones and contours of the image. This technique is discussed in Volume II.

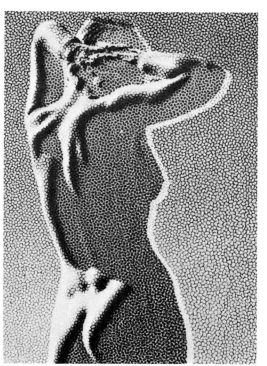

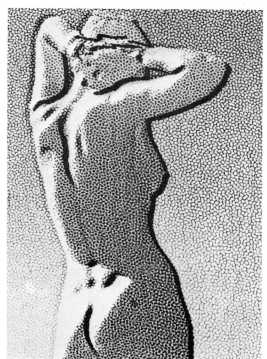

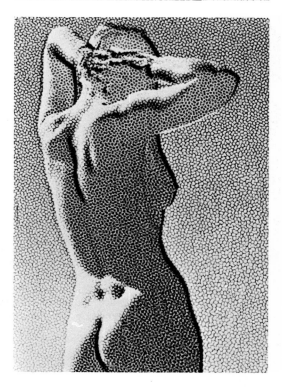

Combinations . . .

. . . of two or more of the graphic control processes is feasible and often leads to particularly effective impressions. Here, reticulation is combined with bas-relief. Typical of these techniques is the fact that no two pictures made with their aid will ever be exactly alike. Note, for example, how differences in offset in the two right-hand pictures lead to different outlines: in the picture at the top, the outline is expressive; in the one at the bottom, it is not.

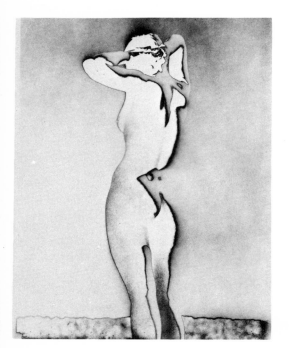 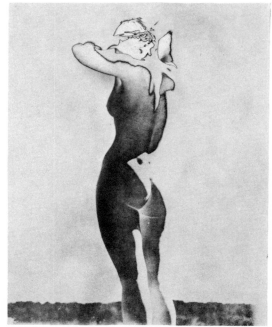

Solarization . . .

. . . or, more accurately, utilization of the Sabattier effect, enables a photographer to combine positive and negative picture elements within the same photograph. This technique lends itself to the production of highly sophisticated images if used with imagination and daring but, in the hands of the tyro, is likely to be disappointing. The surrealistic kind of image which it yields is most effective if the subject of the picture is such that it lends itself to a graphically simplified treatment, i.e., if *design* in terms of black and white, line and form, light and dark, is more important than naturalness of rendition. This technique is also discussed in Volume II.

PREREQUISITES FOR SUCCESS

Experience has taught me that observance of the following rules connected only indirectly with developing and printing can considerably improve the quality of anybody's darkroom work by increasing efficiency and minimizing irritation and waste.

Make cleanliness a fetish. Many processing solutions are sensitive to contamination by other chemicals, sometimes to an extraordinarily high degree. Contaminated solutions work less efficiently or not at all and may stain negatives or prints. Insufficiently cleaned bottles, trays, graduates, print tongs, and so on, dirty towels, and chemicals or traces of solutions carried by hands or fingers from one tray to another are the most common causes of chemical contamination. Handling photographic paper with wet or damp hands causes spots. Accidentally spilled solutions must be wiped up immediately before they have a chance to dry, crystallize and, in the form of fine airborne powder, contaminate the entire darkroom.

Even ordinary dust is a veritable pest when it comes to enlarging, manifesting itself as spots in the print and requiring time-consuming spotting. The experienced darkroom worker knows that one of the smartest investments in terms of time and money saved is to give his darkroom periodic cleanings consisting of a good scrubbing with soap and water augmented by a thorough vacuum cleaning that extends even to the insides of the enlarger. And he never smokes in his darkroom.

Be well organized. In accordance with published instructions modified to fit your particular requirements, establish a *routine*—always performing the same operation in the same manner—then stick to it. Such a system is the best insurance against mistakes caused by accident or forgetfulness. Keep each piece of darkroom equipment in its appointed place where it is handy yet protected against dust and chemical contamination. Be sure that all bottles and other containers are properly identified; if necessary, make your own labels from strips of white, inch-wide surgical tape on which you can write with a ballpoint pen. Keep a pencil and a notebook or clipboard handy and write down everything you wish to remember, including ideas for future work and data that might be useful later. The more highly organized your operation, the smoother and faster the flow of work, the better the results, and the greater your satisfaction.

Keep things simple. On the basis of experiments and tests or following the advice of more experienced colleagues, choose a single brand of film,

then use, as far as practicable, the same manufacturer's other products such as developer and fixer. The reason for this suggestion is two-fold: (1) There are slight but sometimes significant differences among the films, developers, and other products made by different manufacturers. To know *one* type of film, developer, and so on *thoroughly* invariably leads to better results than limited knowledge of many. (2) Each manufacturer's line of products is in chemical balance; *i.e.*, his developers, fixers, and so on are compounded to give the best possible results when used with his films.

However, there is one place in the sequence of operations where it is safe to break the chain and switch from one manufacturer's products to another's without upsetting the chemical balance: You can always print one manufacturer's films on another manufacturer's paper. If you do so, it is advisable to use the paper manufacturer's paper developer and fixer because they are specifically balanced for best results with his paper.

Follow the manufacturer's instructions (which always accompany his products), at least as a starter; he knows his product better than you. This is particularly advisable in regard to film development—type and temperature of the developer, time of development, modes of agitation, fixing, and so on—but also in regard to the type of safelight, the mixing of chemical solutions, and other photographic operations. And not before a photographer is quite sure that results are not fully up to expectations should he try to improve on these instructions. The most common deviation will be a change (usually a slight shortening) in the suggested time of film development.

Incidentally, users of Kodak products have at their disposal a gold mine of technical information in the form of three lines of *Kodak Data Books*—Basic, Advanced, and Professional. They are inexpensive, authoritative, and always to the point, and are, in my opinion, indispensable to anyone who works with Kodak products.

The three greatest obstacles to successful darkroom work are *false economy, carelessness*, and *forgetfulness*. Typical examples of false economy are efforts on the part of the photographer to save money by buying little-known brands of film, paper, and chemicals; using a cheap colored lightbulb instead of a more expensive (but safer) filter-equipped safelight; and overworking his solutions. Carelessness is most often manifested in spilled solutions, fingermarks on films and prints, unlabelled bottles leading to disastrous mixups, and using fingers instead of print tongs. And the most glaring example of forgetfulness is to turn on the white room illumination before closing the paper safe, irrevocably ruining the entire supply of photographic paper.

GLOSSARY OF SPECIAL PHOTOTECHNICAL EXPRESSIONS

Like any other in-group, photographers have their own jargon, special expressions which often sound like gibberish to the uninitiated. Memorizing the following terms and their meanings should facilitate your acceptance by the fraternity.

Blowup = a photograph that is larger than the negative from which it was made; to *blow up a negative* means to make an enlargement.

Bracket = a series of negatives (usually three to five) identical in all respects except exposure, from which the photographer afterwards picks the best one for printing. *Bracketing his shots* means making such a series.

Burning in = giving additional exposure during enlarging to negative areas that are undesirably dense (black) in order to improve differentiation in the print.

Contact print = a photograph made in direct contact with the negative and therefore always of the same size as the negative.

Contact sheet = a contact print of all the negatives from one roll of film printed together on the same sheet of 8″ x 10″ or 8½″ x 11″ paper.

Crop = cut. *Cropping a negative* means enlarging only a certain area of it, cutting off, so to speak (actually, omitting) unwanted parts in the print.

Density = degree of blackness in a negative or print.

Developer = any one of many chemical solutions used for transforming the invisible (latent) image on an exposed film into a visible one.

Diapositive = a black-and-white transparency—a "positive negative"—intended either for viewing in transmitted light (projection) or for producing a negative print. Diapositives are made by printing negatives on film (or glass plates) instead of printing them on paper.

Dodger = a device for density control used during enlarging, usually made of cardboard or red celluloid. To *dodge a print* means to affect its density on a local scale and thereby control its contrast range and distribution.

Emulsion = the light-sensitive layer of a film or photographic paper.

Enlargement = a photographic print that is larger than the negative from which it was made.

Enlarger = a projection printer, an instrument indispensable for making a negative yield an enlarged print.

Exposure = the act of admitting light to the film inside the camera by means of the shutter; to *make an exposure* means to take a photograph.

Ferrotyping = giving glossy photographic paper a mirror-like finish by drying it in contact with a ferrotype plate.

Fixer = the chemical solution that renders a developed film (or print on sensitized paper) insensitive to further action by light, clears the film, and makes it printable and permanent.

Flare = the effect on the film of unwanted light, caused by internal reflections in the lens. It can usually be prevented by use of a proper lens shade.

Flat = lacking in contrast; a *flat print* is a photograph that appears too gray. *Flat light* is low in contrast and more or less shadowless.

Flush mounting = mounting a print on a board in such a way that the photograph extends all the way to the edges, with no part of the mount showing.

Fog = a more or less uniform layer of density in a film or print, usually the result of exposure to extraneous light or a harmful chemical reaction during processing. *Fogging a negative or print* means accidentally or occasionally deliberately producing such a layer of overall density.

Forcing = trying to increase insufficient density in an underexposed negative or print during development, usually by extending the duration of development beyond what is considered normal.

Frame = any individual negative on a roll of developed film. Also, foreground subject matter (usually dark) which, like the frame of a painting, partly or entirely encloses the main subject of the picture. *Framing the subject* means surrounding the subject with foreground material in such a way that, in the picture, it appears to be framed.

Gradation = contrast range, the span between the highest and lowest densities in a negative or print.

Grain sharp = an enlargement that is critically sharp over its entire area; sharp enough to distinguish the film grain, the light-blackened silver particles of a developed photographic emulsion which produce the image.

Halation = light spilling over into the darker areas of the negative or print, usually the result of shooting toward a strong source of light or considerable overexposure of the film. Also, certain manifestations of unwanted light.

Hard = high contrast; a hard negative or a hard paper yields prints of greater-than-average contrast.

High-key = a low-contrast print in primarily light shades of gray dominated by white, making a light and joyous impression.

Highlights = the densest (blackest) areas in a negative or, conversely, the lightest areas in a print.

Holding back = giving less-than-average exposure during enlarging to those areas of a negative which otherwise would appear too dark in the print.

Hypo = *sodium thiosulfate,* a salt used in the form of a watery solution for the removal of the unexposed silver salts from the developed negatives or prints.

Intensifier = any one of several chemical solutions used to increase inadequate density in underexposed negatives or prints.

Latent image = the invisible image produced within a photographic emulsion by the action of light; development transforms a latent image into a visible one and an exposed film into a negative.

Low-key = a low-contrast print in primarily dark shades of gray dominated by black, making a dark and somber impression.

Mask = (1) a frame cut out of thin, black paper placed in contact with the film during enlargement of only part of the negative; its rectangular opening corresponds to the area of the negative that is to be shown in the print and its borders prevent harmful stray light from reaching and possibly fogging the sensitized paper. (2) A low-contrast, low-density, positive contact print of the negative made on film; taped to the negative in register, its purpose is to reduce the contrast of an overly contrasty negative to a printable level. *Masking a negative* can mean either framing it with a paper mask, or lowering its contrast with a density mask.

Negative = a developed film showing the image of the depicted subject in reversed tonal gradation, *i.e.,* light areas of the subject appear dark and dark areas light.

Oyster shell marks = irregular, more or less concentric cracks in the glossy surface of a ferrotyped print caused by its premature removal from the ferrotype plate.

Photomural = a large photographic print, usually larger than 30″ x 40″.

Print = professional photographers call *any photograph on paper* a print, regardless of whether it was made by contact printing or with the aid of an enlarger; *printing,* therefore, can mean making either a contact print or an enlargement.

Processing = performing the complete operation of transforming an exposed film or sheet of photographic paper into the finished negative or print.

Proof sheet = a contact print or enlargement displaying all the negatives from one roll of film (or a number of different sheet-film negatives) on the same sheet of paper.

Reducer = any one of several chemical solutions used to decrease excessive density in overexposed or overdeveloped negatives or prints.

Safelight = a light (or lamp) used to illuminate a photographic darkroom

which, because of its particular color (spectral composition), does not affect sensitized photographic material. Differently sensitized materials require safelights of different colors.

Shadows = the thin (transparent) areas of a negative and, conversely, the dense (black) areas of a print.

Shoot = to take a picture; professionals don't photograph; they shoot. A *good shot* means a good picture.

Slide = a positive photograph on film (rarely on glass) intended for projection, usually (but not necessarily) made on 35mm color film and mounted in a cardboard frame or between two cover glasses in a plastic or metal frame.

Soft = low in contrast; a soft negative or a soft paper yields prints of lower-than-average contrast.

Solarization = partial or total reversal of the image in a negative or print as a result of enormous overexposure. True solarization—the Sabattier effect —occurs only rarely and then mostly in negatives. The process of solarization described in Volume II involves a phenomenon that actually should be called "pseudo-solarization."

Soup = a common professional slang expression meaning developer. *Souping a film* means developing a film.

Straight print = a print all the areas of which received identical exposure, *i.e.*, a print that was not contrast-controlled by means of dodging, holding back, or burning in.

Stray light = harmful, unwanted light in the darkroom that fogs film and sensitized paper.

Take = all the photographs made or films exposed at one time, of one subject, during one day, or on one assignment.

Toning = changing the color of the image of a print by chemical means, for example, from the ordinary shades of gray to shades of brown or blue. A *toner* is a chemical solution used for this purpose.

Transparency = a positive photograph on film, usually (but not necessarily) in color, made on film larger than 35mm, and intended either for projection or reproduction with photomechanical means. A 35mm transparency is usually called *a slide*.

MAKING A PHOTOGRAPH

Making a black-and-white photograph is basically a three-step process: The first two steps—taking the picture and developing the film—produce a *negative*; the third step—contact printing or enlarging—produces *a print*. To put these operations into proper perspective and assess their influence upon the final picture, let us examine what happens each time we make a photograph.

Light radiating from the sun or a lamp in conjunction with light reflected from nearby surfaces, clouds, and so on illuminates the subject and is in turn reflected by it into the lens of the camera.

The lens gathers the light that strikes it, forms an image of the subject, and if focused accordingly, projects this image onto the film.

The film (more precisely, the light-sensitive coating of the film, the *emulsion*), within certain limits, responds proportionally to the light which is transmitted by the lens. A chemical reaction takes place between the incident light and the light-sensitive silver salts (halides) imbedded in the emulsion as a result of which a *latent, i.e.*, invisible, image of the subject is formed on the film.

Development, which must take place in near or, preferably, total darkness (pp. 58–75), turns the latent image into a visible one, the active ingredients of the developer converting the light-struck silver salts into metallic silver more or less in proportion to the exposure which they received. The result is an image of the subject in which the values of light and dark are reversed: Subject areas that were comparatively light (and reflected a correspondingly large amount of light onto the film) appear relatively dense and black, whereas the darker or more shaded areas of the subject, which reflected less light, appear proportionally lighter and more transparent. The film has become a *negative*.

Fixation. To prevent those light-sensitive silver salts which received only little exposure or none at all from turning black, too, the moment the developed film is exposed to light (which, of course, would destroy the image), the negative must subsequently be made insensitive to light by treating it in a fixer solution. And to make it permanent, it must be freed from all processing chemicals by washing before it can finally be dried.

Printing once more reverses the tonal values of the image. The negative is made to yield a positive picture on paper in which the shades of light and dark correspond more or less to those of the photographed subject. This operation takes place in the darkroom by shining light through the negative onto a sheet of light-sensitive paper. It can be performed in one of two ways: either by placing the negative in contact with the paper (*contact printing*, Vol. II), in which case the picture will have the same size as the negative; or by projecting the negative onto the paper with the aid of an enlarger (*enlarging*, Vol. II), in which case the picture can be almost any size. As with the film, the exposed paper is subsequently developed, fixed, washed, and dried.

Conclusion. The fact that black-and-white photography is a three-step process offers a photographer three chances for controlling the effect of his picture:

Before he takes the picture, i.e., prior to releasing the shutter, he can, through appropriate choice of subject distance and angle of view, type of lens, filter, and film, f/stop–shutter speed combination, type, color, and direction of the light, and a multitude of other means, control the outcome of his picture in almost any conceivable respect.

By developing his film accordingly, he can, within certain limits, control the contrast gradient and the degree of graininess of his future picture (pp. 65 and 66).

By printing his negative accordingly, he can, within certain limits, further influence the contrast gradient and also control the lightness or darkness, size and proportions, manner of cropping, perspective, and form of graphic rendition of his print (Vol. II).

Final conclusion. Experienced photographers, aware of the fact that it is easier to prevent than to correct faults of a photograph, take great care to control their future picture by making all the necessary arrangements *before* they release the shutter.

II. The darkroom

Since some stages of film development must take place in near or total darkness and printing requires near darkness, a darkroom, obviously, is a photographic necessity. However, the practical execution of these operattions allows for a certain flexibility, as a result of which photographers have the choice of three types of working arrangement:

THE SUBSTITUTE DARKROOM

If circumstances prohibit the installation of a permanent darkroom, photographers can still develop their films if they use a *lighttight tank* that can be filled with solutions and drained in daylight. With such a tank, the only operation requiring total darkness would be loading the tank with film. If one lacks a darkroom, one can do this in one of two ways: either in an ordinary, windowless *closet*, the door of which can easily be made lighttight by edge-stripping or with the aid of an inside or outside curtain; or inside a *changing bag* or a *changing box*. A changing bag is a squarish sack made of lighttight fabric with a zipper or snap-closed opening for receiving the tank and film at one end and two short sleeves equipped with elastic bands at the other through which the hands are inserted. And a changing box is a similar device, except that, instead of being made of cloth, it consists of a rigid wooden box equipped with a lighttight hinged lid for loading and two elastic sleeves in front which provide lighttight access to its interior for the hands. The empty developing tank and the roll of film that is to be developed are placed side by side inside the bag or box through the main aperture, which then is closed. The hands are inserted through the lighttight sleeves, and the tank is loaded inside the bag or box by feel. Once the film is in the developing tank and the tank cover on, the tank can safely be taken out of the changing bag or box and the subsequent operations performed by ordinary light. See the illustration on p. 45.

Incidentally, for the development of 35mm films, tanks exist which can be loaded in daylight, thereby eliminating the need for a changing bag. My own experience with this type of tank, however, has not always been a happy one.

Photographic papers are much less sensitive to light than film is. Negatives, therefore, can be printed in any temporary darkroom in which the level of possible stray light at the working place is low enough to pass the test described on p. 32.

THE TEMPORARY DARKROOM

If circumstances prohibit the installation of a permanent darkroom, top-quality photographic work can still be done if films are developed in daylight-loading tanks and negatives printed in an ordinary room the windows of which have been made reasonably lighttight. If such a darkroom is going to be used only at night, drapes or shades of dark fabric are usually adequate for this purpose. For daylight use, more substantial shutters made of plywood or some kind of wallboard, equipped along the edges with a light-seal consisting of strips of black cloth, will probably be required. More practical, but also more expensive, are black, opaque rollshades running in channels of the kind used in lecture halls to darken the room for projection. The test described on p. 32 will quickly tell whether, despite a certain amount of stray light, the room is dark enough for printing.

The kitchen is normally the most suitable place for setting up a temporary darkroom because it provides four desirable features: an *electric outlet, running water, a sink with drain*, and a *working surface* large enough to accommodate an enlarger and the necessary solution trays. The disadvantage, which it shares with most other temporary darkroom installations, is, of course, that it can only be used when not required for its original purpose. Usually, this means working at night.

An ordinary room, because of lack of running water and a sink, is perhaps a less practical substitute for a real darkroom than the kitchen, but it makes up for this drawback by being available for longer and more convenient periods of time. In addition to privacy, it offers plenty of space and an even temperature throughout the year. A large tray filled with water temporarily accommodates the fixed prints which subsequently are washed in the bath-

28

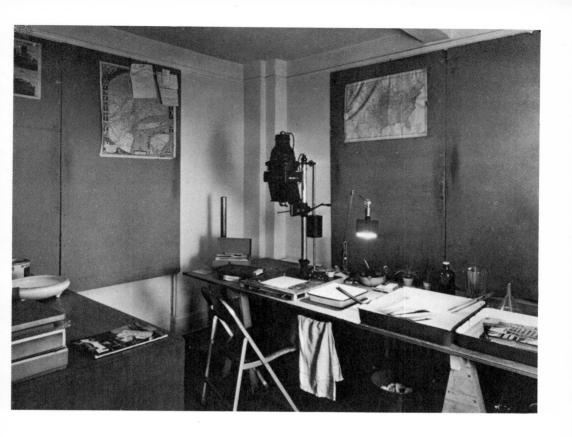

The temporary darkroom

Two views of one of the several temporary darkrooms which the author arranged for his own use over the years. This one is located on the 14th floor of a high-rise apartment house. Despite its four large windows, Masonite panels on wooden frames assured a degree of lighttightness which made printing possible even on a sunny day.

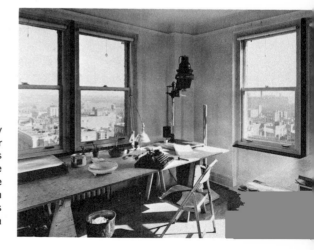

29

room. A thick layer of newspaper over a large sheet of plastic protects the working surface and prevents damage to furniture from accidentally spilled solutions—a possibility which experienced photographers minimize by using special deep trays for fixer and water and by not filling shallow developer trays too full.

The bathroom is usually the least desirable location for a temporary darkroom setup because the worker is never safe from interruptions by other members of the household, unless, of course, a second bathroom exists. If there is no space for a table, a sheet of plywood placed on top of the tub provides the working surface but must be raised sufficiently to make working tolerably comfortable. And even if cabinet space is available, the enlarger, paper, and chemicals must never be kept in a bathroom longer than necessary, because steam and moisture would ruin them in a relatively short time.

THE PERMANENT DARKROOM

The basement of a private home, dry and preferably finished, in which a room can be partitioned off, normally offers the most advantages for a permanent darkroom installation. They are freedom from interruption, adequate space, availability of electricity and running water, and relatively even temperature the year round. Windows, if present at all, are usually small and easily darkened. Remoteness from the rest of the household guarantees privacy and seclusion, prerequisite for any kind of creative work.

The attic of a private home, although offering seclusion and space, often has serious drawbacks: It is too cold in winter and too hot in summer, and running water is usually not available on the same floor. These disadvantages can, of course, be overcome through installation of an electric heater, a room air-conditioner, and a pipe connection to the nearest water supply.

A walk-in closet of the kind usually found only in old houses, provided it is 5′ x 5′ or larger, can easily be converted into a small but efficient darkroom. Adequate ventilation can be provided by a light-proof fan installed above the door. The water problem can be solved as described above in the case of a temporary darkroom installation in an ordinary room.

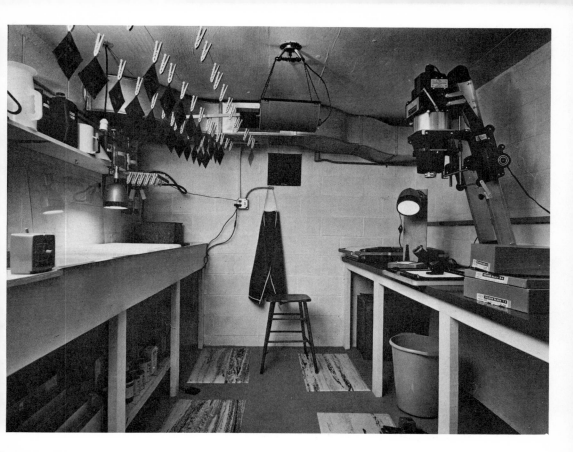

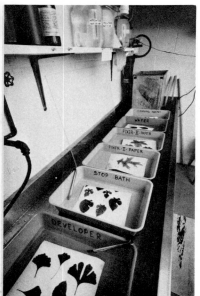

The author's present, permanent darkroom

On the left side, the "wet bench"—a stainless-steel sink running almost the entire length of the room. It contains the developer, stop bath, and fixer trays and the washing tank for films and prints. Above and below are storage shelves. On the right side, the "dry bench" with electric print dryer, enlarger, and photographic paper supply. Note also the fixed ceiling safelight, the movable safelight on the dry bench, the light-tight darkroom exhaust fan (the black square in the end wall), the large waste can, and the apron. A stool and soft floor mats contribute to make working conditions more comfortable.

DARKROOM ORGANIZATION

The efficiency of any darkroom, temporary or permanent, depends almost entirely on its organization plus a lot of apparently insignificant details like the location of a switch, the height of the working surface, or the width of the aisle. In this respect, anybody planning the installation of a darkroom should pay attention to the following:

The floor area of a darkroom should not be smaller than approximately 5′ x 5′. A room 5′ x 8′ large is, of course, more convenient, and 8′ x 12′ is large enough even for very high demands. As a matter of fact, a darkroom can actually be too large, making for unnecessary steps and premature fatigue. For example, in a one-man darkroom, if the width of the aisle between the wet and dry benches exceeds 36 inches, working conditions can already become somewhat tiresome.

Darkness, of course, is an essential prerequisite for any darkroom. However, as mentioned before, the degree of darkness may vary. For proper development of films without the aid of special daylight-loading tanks, total absence of "unsafe" light is a necessity, a requirement which not all so-called darkrooms fulfill. Often, what at first is taken for total darkness, reveals itself, after a period of accommodation by the eye, as only pseudo-darkness pierced by rays or pinpoints of light leaking through cracks in the partitions or around the window or door. Therefore, before he accepts his newly finished darkroom as dark, a photographer should stay in it for at least ten minutes to give his eyes a chance to adapt; if, after this period, he still cannot detect traces of light penetrating through cracks, he can rest assured that his darkroom is actually dark.

To establish the degree of darkness of installations intended only for printing where, as mentioned before, requirements are less severe, performance of the following test is recommended: With the safelight turned off, place a small piece of photographic paper, emulsion side up, on your worktable and put a few coins on it. Leave it exposed like that for at least five minutes, then develop and fix it without turning on the safelight. If the paper remains pure white, whatever stray light may be present is harmless as far as this type of paper is concerned. But if the positions of the coins reveal themselves as white circles on a faintly (or not so faintly) gray background, the amount of stray light is too high, requiring an improvement in the darkening arrangements.

The illumination of a darkroom must provide for two kinds of light: ordinary, or white light for print inspection and cleaning up after work, and colored safelight (p. 46) for developing and printing. In my own darkroom, I prefer the following arrangement: an ordinary 150-watt household bulb in a reflector pointed at the ceiling furnishes the overall illumination required for all before and after processing operations. It works on a switch which, in addition to being mounted in an out-of-the-way place, is so different from all other switches that it cannot possibly be turned on by mistake. This, of course, would be disastrous to open, not-yet processed paper and film. Another smaller, well-shielded white 60-watt bulb is mounted above the sink and connected to a foot switch; it is pointed at the wall behind the fixer tray where wet enlargements can be displayed on an inclined sheet of Lucite, and used for examining and evaluating fixed prints.

Work illumination consists of one or several safelights equipped with suitable filters (p. 46). In the center of the room, a large lamp turned toward the ceiling furnishes indirect overall illumination. A second safelight suspended by a drop cord from the ceiling hangs three feet above the paper developer tray at the left end of the sink. A third safelight, mounted on a swivel, stands next to the enlarger to which it is connected via a foot switch in such a way that when the enlarger lamp goes on, the safelight goes off to facilitate focusing the enlarger lens and, during printing, dodging and burning in.

I know that many photographers employ a special dark green safelight for film development, primarily for loading the tank and, later, inspecting the film toward the end of the development. Personally, I don't think much of this practice, preferring to load my tanks in total darkness and having long since given up film inspection as a waste.

The best color for a darkroom, paradoxical as this may sound, is white, and the best paint is white exterior enamel. A good darkroom is light-proof, and since the only light present is safe, the only kind of light that can reflect from walls and ceiling is, of course, also safe; and the more of this safe light reflected, the better the visibility in the darkroom. White walls and ceiling can therefore be considered an integral part of the darkroom illumination.

The electrical installation should provide for several twin outlets mounted *above* the "dry" bench; better still is installation of an outlet strip. Outlets above the "wet" bench are potential shock hazards and should be avoided.

Since the combination of grounded water pipes, grounded steel sink, metal appliances, wet hands, and electricity makes a darkroom a potentially

hazardous place, take the following precautions: All non-current–carrying metal parts of electric equipment like enlarger, contact printer, drier, electric timer, foot switches, safelights, drymounting press, etc., should be grounded, either by three-wire cord and three-prong plug or by connecting them to a water pipe by means of a copper wire. In addition, the *one-hand rule* should rigidly be observed: When handling an electric appliance or operating an electric switch, the other hand must never touch a grounded metallic or wet object (like a processing solution in a metal tray standing in a steel sink) in order to preclude any possibility of making a direct ground connection and risking a potentially lethal shock. Furthermore, all outlets should be located as close as possible to the respective appliances, electric wires should be as short as practicable, and they should never trail on the floor.

Strict separation of wet and dry operations is one of the most important requirements for the efficient operation of any darkroom. The best arrangement is in the form of two parallel working surfaces: a dry bench for print drier, negatives, contact printer, enlarger, and paper supply; a wet bench for the sink, developing tanks and trays, short-stop bath, fixer, hypo eliminator bath, and film and print washing facilities. Overhead, on wires strung above the wet bench, films and prints are hung up to dry. Drymounting press and paper trimmer, which take up a lot of space, are better located outside the darkroom.

If the size or proportions of the available space prevent this type of layout, an L-shaped or U-shaped arrangement is the next best choice, provided, of course, the basic sequence remains unchanged. The accompanying diagrams show a few proven solutions.

A large, shallow, flat-bottomed sink, preferably of stainless steel equipped with splash guard and installed with at least ¼ inch of pitch per running foot, forms an integral part of the wet bench and is an invaluable aid to efficient darkroom work. Sinks of this kind are available commercially in many different sizes and represent one of the best investments a photographer can make. Tanks, trays, and washing apparatus can be left permanently in such a sink, which effectively prevents wet messes, eliminates the danger of accidental spills, and promotes cleanliness in the darkroom.

Hot and cold running water is a necessity in any permanent darkroom. Preferably, the installation should provide for two sets of mixing faucets, one at either end of the built-in sink. Ideally, at least one of them should be equipped with a thermostatically regulated temperature control valve. The height of the faucets above the sink should not be less than 15 inches—suffi-

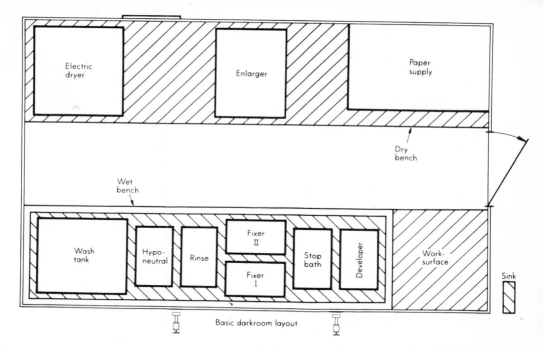

Electric dryer

Enlarger

Paper supply

Dry bench

Wet bench

Wash tank

Hypo-neutral

Rinse

Fixer II

Fixer I

Stop bath

Developer

Work-surface

Sink

Basic darkroom layout

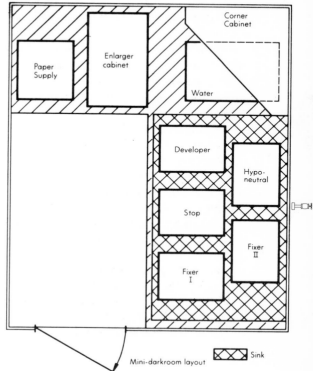

Corner Cabinet

Paper Supply

Enlarger cabinet

Water

Developer

Hypo-neutral

Stop

Fixer II

Fixer I

Mini-darkroom layout

Sink

Above: Layout for a darkroom approximately 8′ × 10′ large, suitable for work of professional quality.

Right: Layout for a mini-darkroom approximately 5′ × 8′ large.

ciently high to fill conveniently a gallon jug or a 3½-gallon film developing tank. Equipping one of the faucets with a length of thin rubber hose makes cleaning tanks and trays easier, prevents splashing, and comes in handy for washing negatives and prints. If the water contains unusual amounts of minerals or iron, installation of a filter is advisable.

The fixed furnishings of a darkroom consist primarily of work benches and storage facilities. In this respect, proper height of the dry and wet benches is a decisive factor in regard to comfort and fatigue. Although tall workers require higher benches than short ones, for people of average height the working surface should be anywhere from 36 to 38 inches above the floor. Ordinary tables are too low, and a board across the bathtub is an invitation to a backache. To provide adequate working space, the width of each bench should be not less than two feet.

An eight-inch wide shelf running the entire length of the wall above the wet bench provides a handy space for bottles of developer, acetic acid, fixer, graduates, timer, thermometer, and so forth and permits the worker to keep these articles in the most convenient place.

A wide shelf below the sink, partitioned by upright slats into different compartments, provides storage space for trays, empty bottles, developing tanks, chemical solutions in bottles, and so on.

Inexpensive, unpainted kitchen cabinets installed below the dry bench are excellent for storing film and boxes of photographic paper, chemicals in factory-sealed bottles and cans, lenses of various focal lengths for the enlarger, pencils, film clips, tape, and other *dry* material. However, be sure to recess such cabinets sufficiently to allow for adequate knee and toe space while working at the bench.

The best covering material for the dry bench is Formica, the next best, linoleum. If the surface is wood without a covering, it should be painted with a chemical-resisting Epoxy paint.

Ventilation and temperature are important but often neglected factors affecting both comfort and efficiency. The ideal darkroom temperature is the same as that of the processing solutions and may be anywhere between 68° and 75°F. Maintenance of these temperatures in winter is possible only if the darkroom is heated, if necessary, by an electric heater installed below the dry bench, in summer, if it is cooled by means of a fan or, preferably, a room air-conditioner. A light-proof, special darkroom fan installed in the window or the wall above the door can contribute markedly to making working conditions more pleasant. A thermostatically controlled mixing valve built into the water supply is almost a necessity if color processing is planned.

THE PERSONAL TOUCH

No two photographers work exactly alike; the more experienced, the more personal their methods are likely to be. While some of these deviations from established procedure may be more quaint than useful, others represent efficient shortcuts and valuable aids to better work. In the latter sense, I am presenting here some improvements that I have found useful.

When doing a lot of darkroom work and particularly when developing sheet films in a tray (p. 88), one's hands make frequent contact with processing solutions. This is unavoidable. To prevent skin irritation, some darkroom workers wear thin rubber gloves. Personally, I found protective hand creams much more satisfactory, and recommend especially the use of Kerodex 71, which is available in most drugstores.

I have the habit of jotting down thoughts and ideas that occur to me during darkroom work and often write negative numbers, paper gradation, and sometimes information relating to dodging and burning in on the back of the photographic paper prior to development. For this I use soft lead pencils of the kind preferred by editors. I found, however, that whenever I reached for a pencil in the dark, I usually got it wrong end first. I put a stop to this annoyance by sharpening these pencils at both ends.

I found the switch for my white light unsatisfactory insofar as it was very small and therefore almost impossible to "hit" in the dark without fumbling. I corrected this deficiency by hinging a 1½″ x 5″ wooden plate to the board supporting the lamp in such a way that its free end rested lightly on the switch, where it was held in place by a rubber band. This relatively large piece of wood is, of course, easy to locate in the dark. All I have to do now is to reach out, swat in the general direction, and presto! the light goes on.

Since I live in the country, it is unavoidable that insects, particularly crickets, find their way into my darkroom. These poor creatures had a habit of falling into the fixer, where they drowned. To prevent this, I bought a large sheet of ¼-inch Lucite, which now covers both fixer trays when they are not in use. Although originally intended to prevent crickets from drowning, this Lucite sheet proved itself unexpectedly useful in two other respects: When making enlargements, I place it upright behind the fixer trays, leaning in a slanting position against the wall, where it serves as an ideal surface on which to slap wet prints for inspection as they come out of the fixer; and when I am through printing, the sheet, once more resting horizontally on the trays, makes a handy surface on which to squeegee the enlargements coming from the washer before they go on the ferrotype plate or are hung up to dry.

Darkroom illumination. *Left:* White-light lamp with switch designed to be "hit" without fumbling (see p. 37). The two other switches control the dropcord safelight above the developer tray and the indirect ceiling safelight, respectively. Accidental confusion of the white-light and safelight switches is impossible. *Right:* The home-mounted Kodak safelight can easily be shifted around and adjusted in any desired way.

As an aid to memory, I clipped the table of suggested developing times at different temperatures from the instruction sheet that accompanies all Kodak films and taped it to the edge of the shelf above the sink, opposite the place where I develop my films. Now all I have to do is check the developer temperature with a thermometer, look up, and find the corresponding time of development right in front of my eyes.

Finding a permanently attached safelight next to the enlarger too rigid, I built a simple, L-shaped stand from a block of wood and a piece of plywood, then mounted the safelight on it in such a way that it is still free to swivel. Now it is very easy to place the safelight in any desired position or, if I find it is in the way, to remove it entirely.

One of the most practical darkroom accessories is a foot switch for the enlarger lamp. It is still more useful if it is connected to the safelight illuminating the area next to the enlarger in such a way that the safelight goes off the moment the enlarger lamp goes on.

A sheet of Lucite 20" × 30" large and one-quarter inch thick, has several functions: *Above, left,* it serves to cover the fixer trays when the darkroom is not in use. *Above, right,* leaning against the wall, it serves as an inspection board for prints just out of the fixer; notice the shielded white-light lamp above it which is activated by means of a foot switch. *Below,* it provides a handy surface for squeegeeing prints onto ferrotype plates *(left)* or freeing them from surface moisture with a viscose cloth *(right)* before they are hung up to dry.

Dodgers for "burning in" and "holding back" during printing. Notice that each wire handle (made from coat hangers) carries two different "heads," one at either end, doubling the usefulness of each dodger. Pieces of white tape serve to make the dodger easier to find in the dark. Cardboard cards for burning-in purposes should be available with holes in different sizes and shapes.

Although dodgers (Vol. II) can be bought in any photo store, I prefer to make my own, cutting a piece of cardboard in the desired shape and attaching it with black photographic tape to a handle made from a wire coat hanger. I used to keep these dodgers lying around on the dry bench where they had a habit of getting lost among other things or, worse, disappearing underneath the baseboard of the enlarger. Now, when not in use, my dodgers are kept in the well that forms the base of my Simmons Omega 4″ x 5″ enlarger, where they are handy, yet out of the way.

Contact printers come in all shapes and sizes, most of them expensive. A first-class contact printer, however, can be made by hinging an 9″ x 12″ piece of quarter-inch plate glass with inch-wide surgical tape to a plywood base. To avoid cut fingers, the edges of the glass should be rounded by rubbing them against a piece of sandstone or a brick. Prints are exposed under the enlarger light. The cost is negligible, the results are tops.

Adequate washing of prints is often a problem since, in my opinion, syphon-type print washers are ineffective. Personally, I prefer washing my prints suspended on (home-made) cork clips in a tank which drains, via two standpipes built into the front corners, from the bottom. The tank, of galvanized steel, was made for me by a local sheet metal contractor. The illustrations on pp. 42–43 show details of its construction.

A home-made contact printer. *Top left:* with a "permanent-ink" felt-tip pen, draw a 9" × 12" large rectangle centrally located below the enlarger lens on the baseboard of your enlarger. *Top right:* Take the lens out of the enlarger; then, by safelight illumination, place a sheet of contact-printing paper within the rectangle. *Bottom left:* Place the negatives on top of the paper; 4" × 5" negatives are held in a *Print File Negative Preserver* (p. 92) which permits contact printing right through the plastic sleeves. *Bottom right:* Place a sheet of quarter-inch plate glass on top of the films to hold them down flat, then expose the paper with the enlarger lamp. Detailed instructions for contact printing are given in Volume II.

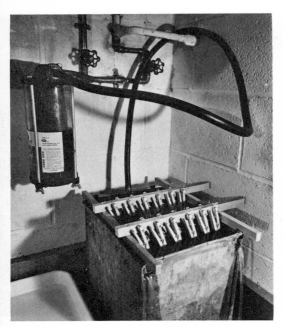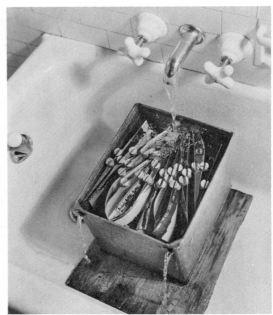

Home-made washing equipment for negatives and prints. *Left:* Washing tank with rack holding sheet-film negatives; my present tank measures 12″ × 17″ × 16″. The device on the left side is a water filter. *Right:* Washing prints suspended from home-made cork clips. To make the cork clips, split bottle corks in half, shape and groove them, then join the halves with rubber bands. Inch-long corks are most suitable.

In the course of my work I constantly have to develop up to half a dozen sheet films at a time in an open tray (p. 88). Washing the processed films presented a problem until I built the wooden rack illustrated here. It accommodates up to 20 negatives suspended on wooden clips. The loaded rack is placed on top of the print-washing tank described above, and the films are washed with the aid of the spray head (made to my specifications by a local plumber) illustrated on p. 43. This spray head clips onto the short end of the washing tank and delivers a finely divided stream of water, a washing method which has proved extremely effective.

Instead of a solid door for their darkroom, some photographers prefer an arrangement consisting of a double, widely overlapping curtain made of heavy black fabric trailing on the floor because it is more easily installed than a door and, when open, requires less space. Such an installation is particularly effective if the darkroom opens onto a relatively dark corridor or hall where stray light is negligible.

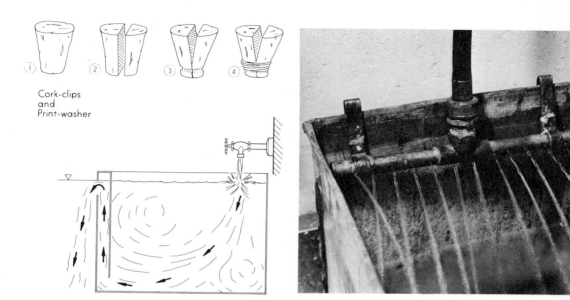

Cork-clips
and
Print-washer

Top left: Section through washing tank shows how heavy, hypo-laden water is withdrawn from the bottom of the tank by means of standpipes built into the front corners of the tank. Top right: The spray-head used for washing negatives. Bottom left: Film rack loaded with negatives. Bottom right: Roll films are washed suspended by wooden clips clipped to two stiff, galvanized wires temporarily hooked over the sides of the tank.

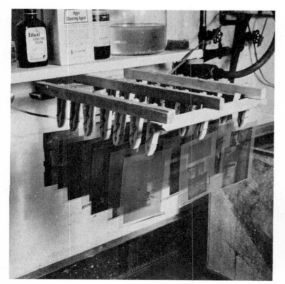

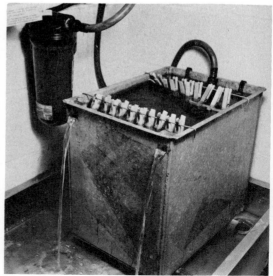

III. Equipment and Material

The following shopping list is intended as a guide to photographers who are ready to furnish their first darkroom. It contains only items which, in my opinion, are indispensable for the satisfactory development of black-and-white films. (Equipment and material for printing are listed in Volume II). Subsequently, each item mentioned in this checklist will be discussed in some detail.

The equipment for film development

Developing tank	Funnels	Viscose sponges
Safelight	Stirring rods	Towel
Thermometer	Film clips	Wastebasket
Timer	Scissors	High stool
Graduates	Negative punch	Floor mats
Bottles	Apron	

The material for film development

Film developer	Wetting agent	Pencil and paper
Acid stop bath	Absorbent cotton	Felt-tipped ink marker
Fixer (hypo)	Filter paper	White petroleum jelly
Hypo eliminator	Tape	Kerodex 71 hand cream

THE EQUIPMENT

Equipment is a capital investment forming the tools of our craft. Hopefully, they will be used for years to come. Photographers who take their hobby seriously are urged to stay away from cheap darkroom kits and buy instead high-quality products from a reputable photo store. If there is none near you, order by mail through the ads in photo magazines.

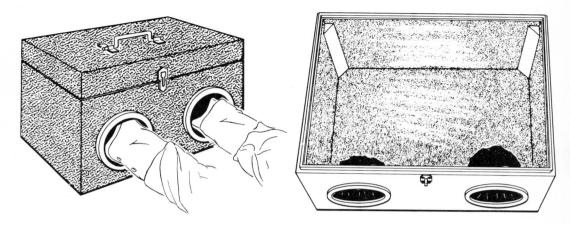

This is a changing box. It enables a photographer to develop 35mm and roll film without benefit of a darkroom—film can be loaded into a lightproof developing tank in daylight. For instructions, see p. 27. *Left:* Outside view of the box; *right:* a look inside with the box lid removed.

Developing tank. The main consideration is that the size of the tank should fit the size of the film that is to be developed. Three basically different designs are available:

Tanks that are not light-proof require that all the different operations such as loading the tank with film, developing, and fixing be performed in darkness. As far as the amateur is concerned, such tanks are used today only for sheet-film and filmpack processing.

Daylight-developing tanks must be loaded with film in darkness (p. 83), but, once loaded and closed, they can safely be taken out into the light. The cover of these tanks has a light-proof opening for solutions which permits filling and draining in daylight. The tank itself is cylindrical and made of plastic or stainless steel. Inside, a plastic or stainless steel reel holds the film, which is held in place in the form of a spiral and its coils separated from one another, either by the spiral grooves of the reel, or with the aid of a separate plastic apron, depending on the type of tank. If an apron is used, two rolls of film can, at least theoretically, be developed simultaneously if placed back to back. The fill-in opening in the cover of most plastic tanks permits insertion of a thermometer or a special stirring rod by which to agitate (p. 72) the developing film, a feature that stainless steel covers lack. Most tanks accept only a single reel and permit development of only one roll of film at a time; some tanks feature an adjustable reel that can be set to accept different sizes of roll film; others are deep enough to hold two or more separate reels. Because of the great number of different types and makes available, the best way to acquire the kind of developing tank that is most suited to his needs is for a photographer to visit a good photo store and

ask the salesman for a demonstration. Detailed instructions for loading and use accompany any new tank, making it unnecessary here to give specific recommendations which, because of the great variety of design features, would be impractical anyway—except for one: When drying *plastic* film reels (a vital necessity before loading the next roll of film since moisture clinging to *any* reel would make reel and film stick together hopelessly), don't use excessive heat, like placing the reel on a hot radiator, since this might lead to warping. Stainless steel reels, of course, will tolerate almost any amount of heat.

Daylight-loading tanks, a type made only for 35mm films, can be loaded with film in daylight and, as far as film processing is concerned, eliminate not only the need for a darkroom, but also the necessity for loading the developing tank in a dark place. My own experience with this type of tank, however, has not always been good.

Safelight. The purpose of a safelight is to furnish darkroom illumination that is (1) safe, *i.e.*, dark enough so as not to fog sensitized photographic material and (2) bright enough to provide satisfactory overall visibility in the darkroom and to enable the photographer to judge accurately the lightness or darkness of his developing print. These conditions will be fulfilled if the photographer buys the type of safelight which the respective film or paper manufacturer recommends for use with his product and then uses it in accordance with the accompanying instructions, paying particular attention to the *maximum wattage of the lightbulb* which may be used and the *minimum distance from the light-sensitive material* at which the safelight is still safe.

Differently sensitized kinds of photographic material require, of course, different kinds of safelight filters. The best way to make sure that the proper filter is used is to follow the respective film or paper manufacturer's recommendations. The following three filter colors are most commonly used in film development. (I add the Kodak filter designations since I use Kodak material; other manufacturers use different code numbers.)

Dark green (Kodak Safelight Filter No. 3) for panchromatic film development. I prefer to process pan films in total darkness, turning on my indirect Kodak OC ceiling safelight after the films have been in the fixer for at least two minutes. Developing pan films by inspection is, at least in my experience, a waste.

Dark red (Kodak Safelight Filter No. 2) for orthochromatic film development. This filter may be used for brief inspections toward the end of the development.

46

Green (Kodak Safelight Filter No. 7) for the development of infrared-sensitized film. Again, I recommend instead development in total darkness.

Thermometer, for checking the temperature of processing solutions. Over the critical range of 68–80° F., it should, and for color processing must, be accurate to within one-half of one degree. Two types are available: mercury-in-glass and dial thermometers. The first are usually more accurate, the second easier to read. Experienced photographers often have both, check the second against the first, then use the more convenient dial thermometer.

Timer, indispensable for timing the duration of film development. Spring-driven timers are adequate for all normal purposes except the automatic timing of print exposure during enlarging, for which electric interval timers coupled to the enlarger switch are required. If dodging or burning in is involved (Vol. II), however, automatic timers are practically useless. In that case, seconds should be measured by slowly counting one-and-twenty, two-and-twenty, three-and-twenty, and so forth. With practice, anyone can learn to time print exposures with a very high degree of accuracy; check yourself against the second hand of your watch.

Graduates are used to measure liquids accurately and to dissolve chemicals. I have three; two large ones of one-gallon and 500cc capacity, respectively, and a small, cylindrical one for precisely measuring small amounts of liquid. For use up to 500cc I prefer clear plastic ones; for larger graduates, stainless steel.

Bottles are used for storing processing solutions. How many bottles are needed and in what size depend on the individual requirements of the photographer, who should keep in mind that developer solutions, if they are kept in prolonged contact with air, are subject to more or less rapid deterioration through oxidation. Developer stock solutions should therefore be stored in such a way that bottles are filled to the very top. In other words, choose the size of your developer bottles in accordance with the capacity of your developing tanks and trays. For example, when dissolving a can of developer powder intended to yield one gallon of developer solution, don't store the resulting stock solution in a gallon bottle where, after the first withdrawal, air admitted to the bottle would oxidize the remaining developer. Instead, divide it among a number of smaller bottles, each filled all the way to the top, each preferably holding no more than what can be used up during one developing session.

Bottles are made of either plastic or glass. I prefer polyethylene bottles, which have the great advantage over glass that they don't break. Color makes no real difference. White bottles are somewhat more practical than brown bottles because they are more translucent and show the solution level more clearly. It is true that strong light has a deteriorating influence on some developers, as a result of which photographers used to keep their developers in brown bottles. But if bottles are kept in the darkroom, this consideration does not apply. Much more important than color is identification. Each bottle should be clearly labelled. Strips of inch-wide, white surgical tape make excellent labels, which are highly water-resistant and easily take the ink of a ballpoint pen.

Funnels are required for two purposes: for pouring liquids into bottles and for filtering solutions. Two are usually needed, one large, one small. The best material is stainless steel, the next best, plastic.

Stirring rods are used for stirring dissolving chemicals when you are preparing solutions. Glass rods, which are chemically inert, are best but may break. The more popular plastic stirring rods stain badly if used in the preparation of developers.

Film clips are needed to hang up wet films to dry. Each roll requires two clips, one at either end, the one at the bottom acting as a weight to prevent the drying film from curling. Sheet films need only one clip per negative. Clips made of stainless steel are best, but wooden ones, which are considerably cheaper, are also satisfactory since they are only exposed to water.

Scissors are required for trimming the ends of film strips and cutting finished rolls into sections, since 35mm and roll-film negatives should be stored not rolled, but flat. Particularly suitable are barber shears with three-inch blades.

Negative punch. In my opinion, the best way to identify a specific frame (individual negative) on a roll of film and mark it for printing is by means of a negative punch. This is a gadget similar to the punch used by railroad ticket collectors to cancel tickets, except that it does not make a hole in the negative, but clips instead a tiny, semi-circular piece out of the edge of the film, leaving a mark which can easily be felt even in the dark. The punch I use is the Punch Rite, Model No. 45-N, and is made by the P. J. Mieth Mfg. Co. in Kenilworth, N. J.

Apron. Many photographic processing solutions produce indelible stains if permitted to come in contact with clothing. A large, plastic darkroom apron prevents this. Wearing a laboratory technician's white or beige smock may look more elegant but is less efficient because its fabric is easily penetrated by chemical solutions.

Viscose sponges. Before processed films can be hung up to dry, they must be freed from water drops, loose particles of emulsion, scum, and so on. The best way to do this is with the aid of two viscose sponges (one on either side of the film) or a gadget consisting of two viscose sponges attached to the two free ends of a U-shaped handle of stainless steel with which the wet film is gently stroked. Before each use, the sponges must be wetted and squeezed dry repeatedly to soften them and remove particles of foreign matter which might have embedded themselves in the sponge. If left there, they might scratch the film. When not in use, these sponges should be carefully protected against dust and chemical contamination and must not be used for any other purpose.

Towels. You should rinse your hands immediately if you get solutions on them. Since wet hands produce indelible stains on film and photographic paper, you must dry them carefully; hence, the towels. I use three: One towel is draped over the drawstring of my darkroom apron and thus is always handy; another one hangs near the wash tank; and a third dry one is kept in reserve in case one of the others should get too wet. To prevent possible creeping contamination with chemicals, these towels must be washed periodically. A roll of paper towels would, of course, do, too, but would also produce lint—and lint is a dirty word in any darkroom worker's vocabulary.

Wastebasket—an important factor in promoting darkroom cleanliness. Don't make the mistake of choosing a trash can that is too small. I found a medium-size plastic garbage can most satisfactory.

High stool. This item is often overlooked but you will appreciate it mightily toward the end of a prolonged session.

Floor mats. Several floor mats with ribbed vinyl tops and non absorbent vinyl cushion bottoms, strategically placed in front of the enlarger, developer tray, drier, and so on, are a boon to tired feet.

THE MATERIALS

Material means "consumables"—things that get used up during processing.

Film developers

A very large number of differently composed developers with different characteristics are available to the discriminating photographer who takes the time and trouble to search for the kind of developer that precisely corresponds to his demands. Some of these developers are available in photo stores in prepared form, either as liquids or as powders, and all a photographer has to do is to add water in accordance with the accompanying instructions. Other developers must be prepared from individually procured chemicals by the photographer himself on the basis of published formulas. (Good sources are the *Kodak Professional Data Book J-1* and *Developing* by C. I. Jacobson, Amphoto, Focal Press.)

Prepared developers have the following advantages over self-mixed developers: They are tested and reliable, uniform from bottle to bottle or can to can, and easy to prepare for use since all they require is the addition of water; and they eliminate the need for acquiring a darkroom balance, buying, storing, and maintaining in fresh condition an assortment of chemicals in special containers, devoting time to compounding formulas, and risking failure because of improperly mixed solutions.

User-mixed developers, on the other hand, have the following advantages over prepared developers: *Versatility*—only relatively few chemicals are needed to compound a large number of developers which, because of variations in the proportions of their components, have different characteristics. As a result, user-mixed developers can easily be modified in accordance with specific needs. *Economy*—preparing a developer from chemicals bought in bulk is less expensive than buying it in ready-mixed form. *Specificity*—the number of published developer formulas which form the basis for user-mixed solutions is ever so much larger than the number of readily available, prepared developers. Photographers who wish to try their hand at self-mixing will find specific instructions in the chapter on chemistry beginning on p. 117.

50

The types of film developers

All film developers, no matter how simple or complex their composition, belong to only a few groups, each group containing developers with the same main characteristics. In this respect, in order to be able to make the proper choice, photographers must distinguish among the following groups (still others exist but are of little or no interest to the reader of this book):

> **Standard developers**
> **Fine-grain developers**
> **High-contrast developers**
> **Monobaths**

Standard developers produce negatives with moderately fine grain, full shadow detail, and normal contrast. They permit the photographer to utilize the full inherent speed of a film and are particularly suitable for developing high-speed 35mm films and all films exposed under average conditions from 120 and 220 roll film on up to the largest size. Formulas for user-mixing standard developers usually allow for variations in the composition of the developer in order to modify it for the production of negatives which can, in regard to contrast, be either soft, normal, or hard. This is an advantage which, to some extent, can be matched with ready-mixed developers through appropriate changes in the time of development. (More specific instructions will be found on p. 72.) Typical representatives of this group are the Kodak Developers DK-50 and D-76.

Fine-grain developers produce negatives with somewhat finer grain structure and lower contrast than standard developers. A few require increases in exposure of the film (consult the manufacturer's instructions), a drawback which, in practice, amounts to a loss of film speed. Still others allegedly increase film speed. Developers belonging to this group are intended primarily for developing 35mm and smaller films of "average" speeds (from ASA 125 to 250), which require relatively high degrees of enlargement, where it is desirable to keep the film grain as small as possible. In my opinion, they are totally unsuitable for developing 120 and 220 roll film and larger negatives, and are of questionable value even for developing ultra-fine-grain and high-speed 35mm films.

Fine-grain developers come in a great variety of different brands for which fantastic claims are sometimes made. Nowhere among photographers are opinions stronger and loyalties greater than in the field of fine-grain development. It has been my experience that many standard developers

produce a film grain that is virtually as small as that produced by special fine-grain developers if film exposure has been adequate, development somewhat shortened, and negatives developed to the same low contrast as that of fine-grain-developed films. Furthermore, developing typical fine-grain films in a fine-grain developer is often undesirable because it may entail a further loss of speed of these already relatively slow films while contributing little or nothing to reducing their already very fine grain structure. The main advantage of fine-grain developers seems to me to be the fact that they make it somewhat more difficult to overdevelop a film. A typical representative of this group of developers is Kodak Microdol-X.

High-contrast developers produce negatives of higher than normal contrast and are intended for use in cases in which high contrast is a desirable negative quality as, for example, in line drawing and black-and-white reproduction work. Experimentally inclined photographers will find them useful for solarizations (Vol. II), bas-relief effects (Vol. II), graphic abstractions, and all types of work involving a more or less pure rendition of blacks and whites. Typical representatives of this group are the Kodak developers D-8 for extra high contrast and D-11 for more moderate high-contrast work.

Monobaths enable a photographer to combine in one operation two normally separate processes, development and fixation. Advantages claimed for this unusual method of film processing are: simplicity; the fact that it eliminates the need for precise timing; and minimization of the effects of solution temperature and mode of agitation upon the developing film. However, in my opinion, this technique is still far from perfect and has the further disadvantage that it makes it impossible to modify the development in accordance with the specific requirements of the type of film, the exposure, the subject contrast, or the desired negative gradation. Experimentally inclined photographers will probably be able to get a monobath developer at their photo store; a number of different formulas have been described in *Developing* by C. I. Jacobson (Amphoto, Focal Press.)

General advice and considerations. In my experience, the surest way to find the "best" developer and produce satisfactory negatives is to start with a developer that the respective film manufacturer recommends, then follow up by obeying his processing instructions to the letter. Until he has made very sure that unsatisfactory results are not due to incorrect film exposure or careless development, a photographer should not try a different developer or deviate from standard procedure.

A further reason for first trying the type of developer that a manufacturer recommends for his film is the fact that some developers contain chemicals that dissolve silver. Although this is immaterial as far as relatively large film formats are concerned (where the degree of negative enlargement normally is rather small), if these developers are used to develop 35mm films, the result would be a deterioration of image sharpness (acutance) because of the silver-dissolving action of the developer.

Developing roll after roll in the same batch of developer weakens its potency. To compensate for this loss of strength, some photographers increase the time of development slightly for each successive roll. In my opinion, this method is too inaccurate to yield predictable results. A better way to make up for the gradual decline of the developer is to rejuvenate it from time to time by adding an appropriate amount of a *replenisher solution*, which many manufacturers provide just for this purpose. Replenishing an aging developer has the further advantage that it makes up for the amount of solution lost through absorption by the films. In this way, the maximum yield can be squeezed out of the working life of a developer.

A still more accurate, although more expensive way of film development is based on the concept of the *one-shot developer*. According to this method, the developer is used only once, then discarded. If films are developed in relatively large tanks, this kind of development is, of course, not only too uneconomical to be practical, but also unnecessary since the amount of solution is very large relative to the film area it has to develop. If roll films are hand-developed by the *see-saw method* (p. 85), however, or if up to six sheets of sheet film have to be developed in a small tray (p. 88), the results that the technique of one-shot development is capable of yielding cannot be matched, as far as predictability and uniformity are concerned, by any other method.

All developers are subject to the oxidizing effects of air. Therefore, when putting a freshly prepared developer stock solution into bottles, make sure they are filled all the way to the top, right up into the neck of each bottle. One of the advantages of plastic bottles is that they can be squeezed; by gently squeezing them a photographer can get rid of that last bit of air before he puts the screw top on tightly. Photographers who use glass bottles can instead drop glass pellets into the bottle until the solution level has risen to the very top.

The keeping properties of different developers vary widely, depending on the type of developer, the concentration of the solution, and the conditions under which it is stored. Usually, the more concentrated the solution, the longer its shelf life. Liquid developers in factory-sealed bottles have a longer shelf life than the same developer once the bottle has been opened.

Used solutions deteriorate relatively fast and, in some cases, cannot be kept at all. The keeping properties of some Kodak developers are listed in the table on p. 131.

Even an unused developer solution deteriorates in time, gradually becomes less potent, and finally ceases to work at all. Therefore, experienced photographers write the date of preparation on each bottle of stock solution, and also the number of rolls that have so far been developed in a specific developer, in order to discard the solution *before* it is exhausted and has ruined a batch of film.

Acid stop bath

Immediately upon termination of the development, films and papers should be treated in an acid rinse, or stop bath, which has the following functions: It quickly neutralizes the alkaline developer which has been absorbed by the emulsion and thereby stops further development; by delivering the film or paper into the fixer in an acid instead of an alkaline condition, it prolongs the acidity and hardening ability and thereby the useful life of the fixer while at the same time reducing the probability of sludge formation; and with film, it reduces the danger of dichroic fog, while with prints, it minimizes the possibility of staining in the fixer as a result of insufficient agitation.

A user-mixed stop bath consists of 30cc of glacial acetic acid (or 125cc of 28% acetic acid) added to one liter of water. Such a bath has a capacity per liter of approximately 20 rolls of 35mm or 120 film, or their equivalent in a larger film size. To make 28% acetic acid from glacial (99%) acetic acid, add three parts of glacial acetic acid to eight parts of water. Be sure always to pour an acid into water; reversing the process and pouring water into an acid can cause explosive bubbling and spattering with resulting acid burns on hands and face. Prepared acid stop baths are made by Kodak. One of them—Kodak Indicator Stop Bath—contains a dye which, by changing with use from yellow to purple, gives warning that the bath is exhausted and must be replaced by a freshly prepared solution.

Fixer or hypo

The purpose of the fixing bath is to convert the undeveloped light-sensitive silver salts of the film or paper emulsion into water-soluble compounds that can subsequently be removed by washing. The fixing agent most commonly used for this purpose is sodium thiosulfate, popularly known

as *hypo*, which, in a complex two-step reaction, converts the undeveloped silver halides into water-soluble compounds. The nature of this two-step reaction contains a danger of which many photographers are unaware: As the hypo acts on the film emulsion, the milky opaque film gradually becomes more translucent and finally clears up completely; the negative appears to be fixed. This, however, is only an illusion, signifying the end of the first step of the fixing process. Actually, the undeveloped silver halides have only been converted into virtually insoluble argentothiosulphate compounds which, during the second step of the reaction, combine with more hypo to form water-soluble compounds of sodium argentothiosulphate. In other words, if a photographer lets himself be deceived by the clear appearance of his negatives into thinking that they are fixed, and takes them out of the fixer too soon, no amount of washing can later remove all residual silver compounds. Eventually, these will decompose and form the familiar yellow stain so typical of many old negatives and prints.

Proper fixation requires two conditions: The fixer must contain a sufficient amount of fresh hypo (which an exhausted bath does not); and negatives must remain in the fixer at least twice as long as it took them to become clear. The same requirements, of course, apply also to prints. However, this does not mean that the longer negatives and prints are left in the hypo, the better. On the contrary, excessive fixation leads to a deterioration of image quality because, given sufficient time, the hypo will start dissolving the exposed and developed silver with the result that fine shadow detail in the thin areas of negatives will be lost and fine highlight detail in prints will disappear. In addition, hypo-laden negatives and prints require much longer washing times than correctly fixed ones.

To avoid these dangers, experienced photographers use the two-bath system of fixation: In accordance with the instructions that accompany your fixer, prepare two identical fixing baths. Transfer your negatives (or prints) from the acid stop bath to the first fixing bath and leave them there for three to five minutes, agitating frequently. Then take the films (or papers) out of this bath, let them drain until they stop dripping, and transfer them to the second fixing bath, where they are left and agitated periodically for another three to five minutes. Test the first fixer from time to time with the aid of one of the commercially available hypo test solutions. When it shows signs of exhaustion, discard it, replace it with the second bath, and prepare a new second bath from fresh hypo.

In addition to hypo, most fixers contain an acid (usually acetic acid), a hardening agent (potassium alum), and a preservative (sodium sulfite). The purpose of the acid is to intensify the effect of the hardener; the function of the hardener is to prevent excessive softening and swelling of the

film (or paper) emulsion during washing, particularly if temperatures are relatively high; and the task of the preservative is to prevent the acid from decomposing the hypo. Since all these are common chemicals, prepared fixers are relatively cheap and user-mixed fixers even cheaper. Trying to save by overworking the solution is therefore foolish not only because, at best, it can save only pennies, but also because it leads to negatives and prints which will stain and fade in time. Smart photographers are aware of this and make sure that their fixer is always fresh.

Hypo neutralizer

Also called hypo eliminator or hypo-clearing bath, its function is twofold: to insure virtually complete elimination of hypo from negatives and prints, and to shorten the time of the washing process. The degree of hypo elimination by washing depends on two factors: the temperature of the water, and the rate of flow. The colder the water (highest permissible temperature is approximately 80°F.) and the slower the flow, the longer the time required for proper washing. However, to completely remove by washing alone hypo that has penetrated the paper base of prints is difficult, and impossible in cases in which DW paper (Vol. II) has to be washed in water of 60°F. or colder. Treatment of films and papers with one of the commercially available hypo eliminators insures that they are free from potentially dangerous quantities of hypo. To produce prints of archival quality (*i.e.*, prints whose images will last longer than the paper), Kodak recommends the use of its Hypo Clearing Agent solution followed by treatment in a Hypo Eliminator HE-1 bath.

Other materials

Wetting agent. Before leaving his washed negatives to dry, a photographer must carefully remove all water drops which, if left to dry on the film, would leave indelible spots that subsequently would show up prominently in the print. Although water drops can be removed by sponging, a still better way to avoid drying marks is to prevent their formation in the first place. This is done by treating the washed films for half a minute in water to which a wetting agent has been added—a substance which, by breaking down the surface tension of water, makes water wetter, so to speak. If films treated in a wetting agent solution are hung up to dry, instead of collecting on the surface in the form of drops, water will run off freely and

evenly, and a single wipe with a viscose sponge will be sufficient to remove all traces of surface water, particles of gelatin, and so forth. A wetting agent especially prepared for photographic purposes is Kodak Photo-Flo.

Absorbent cotton can serve as an improvised but quite effective filter for removing sludge and emulsion particles from a used developer; simply place a fairly large tuft of absorbent cotton loosely in the funnel used to pour the solution back into the storage bottle.

Filter paper for filtering solutions does a more efficient job than absorbent cotton by also catching small particles which cotton might let through, but it is considerably slower in action.

Tapes of different kinds are invaluable multi-purpose aids in a darkroom. I always have at hand three types: black photographic or masking tape; inch-wide water-resistant white surgical tape; and non-oozing *Scotch Magic Transparent Tape* No. 810. I use them for everything from making labels for bottles to masking negatives or holding things temporarily in place.

Paper towels, although found in many darkrooms, are, in my experience, of questionable value because they are incurable producers of lint—and lint, like dust and chemical contamination, is a darkroom pest which photographers must fight constantly. I prefer cloth towels and viscose sponges.

Pencil and paper are needed constantly: to make notes about replenishing darkroom supplies, jot down ideas, write data on the back of prints, and so on. I found the thick, soft lead pencils which editors use and a clipboard most handy. Hard pencils are unsuitable because they "print through" when used on the back of photographic paper; besides, their writing is too thin to be legible by feeble darkroom light.

A felt-tipped ink marker filled with black, permanent ink which writes on any slick surface such as enamel, glass, and steel may occasionally come in handy.

White petroleum jelly (Vaseline), rubbed very lightly on a scratched negative, fills in such marks so that they are either minimized or don't show at all in the print. A commercially available preparation that serves the same purpose is Scratch-Patch.

Kerodex 71 is the trade name of a protective hand cream which I found extremely effective and pleasant to use. It is available in most drugstores.

IV. How to develop a film

Technically speaking, making a photograph starts with exposing a *film*. Visually, as mentioned before, there is no difference between an unexposed and an exposed piece of film; although the picture is there, it is still in latent form. To bring it out, the film must be *developed*. Development transforms a film into a *negative*. The negative in turn forms the basis for the photograph—the *print*.

As far as phototechnical considerations are concerned, the better the negative, the better the print. The three factors that decide the quality of any negative are *focusing, exposure,* and *development*.

Focusing the camera determines the degree of sharpness of the negative. If the lens was incorrectly focused, the negative is bound to be unsharp, and nothing can subsequently be done about it. Correctly focused, it ought to be sharp but may still be blurred—perhaps because the camera was accidentally moved during the exposure, or because the subject moved so fast that the chosen shutter speed was too slow to freeze its image on the film. But even a sharp negative can yield a blurred print—because the enlarger lens was not focused correctly (Vol. II), or the enlarger was jarred or vibrated while the paper was being exposed, or because the negative buckled out of the plane of focus during the exposure (Vol. II).

Exposure of the film inside the camera determines two aspects of the future negative: sharpness and density. If the selected exposure time is too slow to freeze the image of a moving subject or to prevent the image from becoming blurred because of inadvertent camera shake during the exposure, the negative will be unsharp. And if the exposure was too long or too short relative to the brightness of the illumination and the speed of the film, the negative will be either too dense or too thin to yield a perfect print.

Development of the exposed film determines the following aspects of a negative: density, contrast, graininess, and to some extent sharpness. If the time of development is too long or too short (p. 72), the developer temperature too high or too low (p. 71), and the type of developer (p. 51) not suitable to the type of film, the negative may be too dense, too thin, too contrasty, not contrasty enough, or too grainy, depending on which factor or combination of factors was involved. And overdeveloped or very grainy negatives yield prints that are never quite as sharp as prints made from perfect negatives. What, then, is a *perfect negative*?

THE PERFECT NEGATIVE

A perfect negative is a negative that will yield a perfect print on No. 2 or 3 paper (see Volume II) without the photographer having to resort to all kinds of manipulations like dodging or burning in (see Volume II). Unfortunately, this statement, despite its obviousness, is not very helpful since it only evokes another question: *What is a perfect print?* And it is here that things become complicated because a print that satisfies one photographer may be rejected by another as too light, too dark, too contrasty, or too flat. Furthermore, although normally a print should be "grainless," occasionally pronounced graininess becomes a creative means, deliberately and successfully used by a photographer to enhance the effect of his picture. Similarly, although normally sharpness is one of the prime requisites for a perfect print, occasionally partial or total unsharpness may be required to convey an intangible subject quality to the viewer of the picture. In other words, a negative that is perfect in one case may very well be faulty in another and vice versa. There is no single perfect type of negative, but there are many. To be able to produce the one that will yield the perfect print *in a specific case*, a photographer must tailor his negative to fit the *nature* of his subject, his *concept* of the subject, and the *purpose* of the picture, in regard to the five basic qualities of any negative:

Sharpness
Density
Contrast
Graininess
Cleanliness

Sharpness. Although there is only one kind of sharpness (which, as mentioned before, is primarily a function of focusing), lack of sharpness—unsharpness—can manifest itself in a negative in four different forms:

Overall, non-directional unsharpness is the result of focusing the camera incorrectly or neglecting to focus it at all as, for example, forgetting to change the lens setting of a simple roll-film camera from portrait to landscape, a common oversight since, in the viewfinder, the subject appears always sharp. If the degree of overall unsharpness is only slight (a fault particularly often found in 35mm negatives), it may have been due to one of the following factors: a lens inherently incapable of yielding critically sharp pictures (a fault of some high-speed and all very cheap lenses); a

(Text continued on p. 63)

The four kinds of unsharpness

Shown here in both negative (this page) and positive form (opposite page), are sharp (center rows) and unsharp pictures. In each case, unsharpness resulted from a different cause:

Overall, nondirectional unsharpness (top row, left pictures) is the result of incorrect focusing or forgetting to focus at all.

Partial, nondirectional unsharpness (top row, right pictures) is the result either of incorrect focusing, a

diaphragm aperture that was too large to produce enough sharpness in depth, or both.

Overall sharpness (center rows) is the result of correct focusing in conjunction with an appropriate diaphragm stop and shutter speed.

Partial, directional unsharpness (bottom row, left pictures) is the result of a shutter speed that was too slow to "freeze" the movement of a subject in motion.

Overall, directional unsharpness (bottom row, right pictures) is the result of inadvertent camera movement during the exposure.

The density of a "perfect" negative should be such that if the negative is held against a page of print, the type is barely legible through the densest areas; the thinnest areas should still contain detail. A "straight" print made from the demonstration negative is at the left. Notice the full range of tones from the lightest to the darkest shades with detail apparent in both.

lens suffering from "focus shift" (such lenses bring the image of the subject into sharp focus at different distances from the film, depending on the respective diaphragm stop used; to offset this fault, the lens must be focused with the same diaphragm setting with which the shot is to be made); a lens coated with grime, fingerprints, or condensation (the latter the result of a sudden temperature difference such as taking a camera from freezing outside conditions directly into a heated room and shooting pictures without giving the lens time to warm up).

Partial, non-directional unsharpness is due to one of two causes: Either the camera was inadvertently focused at the wrong distance from the lens so that the background or foreground was rendered sharp instead of the subject, or the lens was not stopped down far enough to extend the depth of the sharply rendered zone sufficiently to include the entire depth of the subject.

Partial, directional unsharpness is the result of a shutter speed that was too low to freeze the image of a subject in motion (only the moving subject is rendered blurred, the static rest of the picture is sharp).

Overall, directional unsharpness is the result of camera movement during the exposure. In that event, the entire picture appears uniformly blurred *in one direction*. In slight cases, this effect may be difficult to distinguish from overall non-directional unsharpness and an examination of the negative under a magnifier may become necessary to establish the cause of the fault.

As far as establishing the degree of sharpness is concerned, for critical demands, examining a negative with the unaided eye is not good enough, particularly if 35mm film is involved. The tool to use is a 5X magnifier. I find the Kodak Achromatic Magnifier 5X particularly useful; the Agfa Lupe 8X gives somewhat higher magnification but has a slightly smaller usable field. The best way to examine a negative is by placing it on a light table or slide viewer. I recommend the Idealite made by Richard Mfg. Co., Van Nuys, Calif.; it has a 10″ x 10″ viewing surface, is only two inches thick, and serves equally well for examining color transparencies or sorting slides.

Density. The crucial factor that *determines the exposure of the print* is the density of the negative. Therefore, the *overall* density of a perfect negative should *always* be such that printing exposures result that are neither abnormally long nor abnormally short. Besides being time-consum-

exposure in conjunction with a slightly shortened time of development in a fine-grain developer yields negatives that are not only softer but also finer-grained than negatives that are the product of a normal exposure in conjunction with normal development in a standard developer. Specifically, correctly exposed fine-grain films of medium speeds developed in a fine-grain developer (p. 51) are capable of yielding negatives that can stand magnification of 10 to 15 times linear (from 35mm to 16″ x 20″) without objectionable grain appearing in the print. And in more average print sizes (up to 11″ x 14″ for 35mm negatives, somewhat larger for larger negatives), the combination of medium-fast film and standard developer (p. 51) should produce virtually grainless enlargements, provided the exposure was generous enough to enable the film to register a sufficient amount of shadow detail and the development short enough to produce negatives of normal contrast yet relatively low overall density. Graininess increases with negative density, which in turn increases with the time of development; and negatives in which contrast is too low require printing on a high-contrast paper. By its very nature this emphasizes the film grain to a higher degree than a paper of soft or normal gradation.

However, it is an interesting fact that high-resolution, fine-grain films do not necessarily deliver the sharpest prints. More precisely, prints can *appear* sharper when made from negatives characterized by a lower degree of resolution and coarser grain. This is particularly apparent in cases in which a low-contrast subject lacks clearly defined outlines or detail as a result of which, in picture form, the eye has nothing on which to focus critically. A grainy print depicting the same subject, however, although equally devoid of differentiation, presents the eye with something on which it can fasten—the film grain. When the grain is the only really sharp component of the print, the grainy print *appears sharper* than the actually sharper grainless one that left the eye at a loss.

Cleanliness. Needless to say, only negatives that are spotlessly clean and free of scratches and other defects can yield perfect prints. In this respect, the three most common, yet most easily avoidable causes for complaints are dust, fingerprints, and marks left by drying water drops. Instructions for avoiding them are given on pp. 19, 82, 83.

lens suffering from "focus shift" (such lenses bring the image of the subject into sharp focus at different distances from the film, depending on the respective diaphragm stop used; to offset this fault, the lens must be focused with the same diaphragm setting with which the shot is to be made); a lens coated with grime, fingerprints, or condensation (the latter the result of a sudden temperature difference such as taking a camera from freezing outside conditions directly into a heated room and shooting pictures without giving the lens time to warm up).

Partial, non-directional unsharpness is due to one of two causes: Either the camera was inadvertently focused at the wrong distance from the lens so that the background or foreground was rendered sharp instead of the subject, or the lens was not stopped down far enough to extend the depth of the sharply rendered zone sufficiently to include the entire depth of the subject.

Partial, directional unsharpness is the result of a shutter speed that was too low to freeze the image of a subject in motion (only the moving subject is rendered blurred, the static rest of the picture is sharp).

Overall, directional unsharpness is the result of camera movement during the exposure. In that event, the entire picture appears uniformly blurred *in one direction.* In slight cases, this effect may be difficult to distinguish from overall non-directional unsharpness and an examination of the negative under a magnifier may become necessary to establish the cause of the fault.

As far as establishing the degree of sharpness is concerned, for critical demands, examining a negative with the unaided eye is not good enough, particularly if 35mm film is involved. The tool to use is a 5X magnifier. I find the Kodak Achromatic Magnifier 5X particularly useful; the Agfa Lupe 8X gives somewhat higher magnification but has a slightly smaller usable field. The best way to examine a negative is by placing it on a light table or slide viewer. I recommend the Idealite made by Richard Mfg. Co., Van Nuys, Calif.; it has a 10″ x 10″ viewing surface, is only two inches thick, and serves equally well for examining color transparencies or sorting slides.

Density. The crucial factor that *determines the exposure of the print* is the density of the negative. Therefore, the *overall* density of a perfect negative should *always* be such that printing exposures result that are neither abnormally long nor abnormally short. Besides being time-consum-

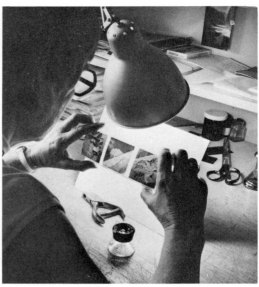

How to examine a negative. The best method is to place the negative on a light table or slide sorter and examine it in transmitted light with the aid of an 8- or 10-power magnifier (*left*). Almost as good a way is to direct the light from a desk lamp onto a piece of white paper or cardboard set up at a slant and holding the negative in front of it (making sure that the lamp light does not strike the front of the negative), then studying it in *reflected* transmitted light (*right*). Notice the magnifier and negative punch (p. 48), the latter used for marking selected negatives for printing.

ing and irritating, very long exposures can cause the enlarger to overheat, the negative to buckle out of the plane of focus, and the paper to become fogged because of excessive exposure to safelight illumination or stray light escaping from the enlarger. Abnormally short exposures make accurate timing very difficult and dodging (see Volume II) virtually impossible. Convenient print exposure times run from approximately 10 to 25 seconds.

Negatives of average subjects are normally considered perfect if they contain printable detail in both highlights and shadows, *i.e.*, if the thinnest areas of the negative—the shadow or darkest areas of the subject—are differentiated and do not consist merely of uniform fog density or flare, and if the densest areas of the negative—the broad highlights of the subject— show gradation and are not merely areas of solid black (which, at best, can be made to appear in the print as undifferentiated gray, giving the picture

a muddy appearance). The brightest highlights, of course, should print pure white in the picture and must therefore be solid black in the negative.

Consequently, provided its gradation is satisfactory, *the thinnest negative that still shows adequate detail in its thinnest areas* is normally the one that should be chosen for printing since, in addition to having the disadvantages listed above, overly dense negatives are less sharp, more grainy, and more difficult to focus than normal ones.

Unsatisfactory negative density is the result either of faulty exposure, faulty development, or a combination of both: Overexposure or overdevelopment yields negatives that are too dense; underexposure or underdevelopment yields negatives that are too thin. For more specific information, see pp. 97 and 111.

Contrast, the crucial factor that *determines the paper gradation*, is equivalent to density range: A high-contrast negative is one in which the difference between areas of highest and lowest density is great; in a low-contrast negative, the difference between the thinnest and densest areas is small. Basically, of course, neither negative type is better than the other (nor, for that matter, better than a normal negative), since certain kinds of pictures require a high degree of contrast to be effective, others a normal one, and still others depend on low contrast to capture the essence of the depicted subject. In most cases, however, the overall density of a perfect negative is such that, regardless of its density range, enlarging it on No. 2 or 3 paper will yield the appropriate print.

Unsatisfactory negative contrast is the result of either abnormal subject contrast (which may have been unusually high or low), choosing the wrong type of film (which may have been too contrasty or too soft), or faulty development. In the latter case, overdevelopment, excessively high developer temperatures (p. 71), or use of a high-contrast developer (p. 52) increases contrast, and underdevelopment, abnormally low developer temperatures, or use of a low-contrast developer decreases the contrast of the negative. (See the illustrations on pp. 76, 110).

Graininess is an inherent property of the film emulsion: Most high-speed films have a coarser grain structure than films of lower speed, while the slowest films are virtually grainless. This characteristic can, however, be modified to a certain degree—minimized as well as emphasized—through an appropriate combination of exposure and development. A slightly prolonged

exposure in conjunction with a slightly shortened time of development in a fine-grain developer yields negatives that are not only softer but also finer-grained than negatives that are the product of a normal exposure in conjunction with normal development in a standard developer. Specifically, correctly exposed fine-grain films of medium speeds developed in a fine-grain developer (p. 51) are capable of yielding negatives that can stand magnification of 10 to 15 times linear (from 35mm to 16" x 20") without objectionable grain appearing in the print. And in more average print sizes (up to 11" x 14" for 35mm negatives, somewhat larger for larger negatives), the combination of medium-fast film and standard developer (p. 51) should produce virtually grainless enlargements, provided the exposure was generous enough to enable the film to register a sufficient amount of shadow detail and the development short enough to produce negatives of normal contrast yet relatively low overall density. Graininess increases with negative density, which in turn increases with the time of development; and negatives in which contrast is too low require printing on a high-contrast paper. By its very nature this emphasizes the film grain to a higher degree than a paper of soft or normal gradation.

However, it is an interesting fact that high-resolution, fine-grain films do not necessarily deliver the sharpest prints. More precisely, prints can *appear* sharper when made from negatives characterized by a lower degree of resolution and coarser grain. This is particularly apparent in cases in which a low-contrast subject lacks clearly defined outlines or detail as a result of which, in picture form, the eye has nothing on which to focus critically. A grainy print depicting the same subject, however, although equally devoid of differentiation, presents the eye with something on which it can fasten—the film grain. When the grain is the only really sharp component of the print, the grainy print *appears sharper* than the actually sharper grainless one that left the eye at a loss.

Cleanliness. Needless to say, only negatives that are spotlessly clean and free of scratches and other defects can yield perfect prints. In this respect, the three most common, yet most easily avoidable causes for complaints are dust, fingerprints, and marks left by drying water drops. Instructions for avoiding them are given on pp. 19, 82, 83.

HOW TO EVALUATE A NEGATIVE

In the normal course of photographic work, the question of which negatives to print and which to pass up is decided on the basis of subject interest and pictorial appeal rather than negative quality. After all, an interesting and meaningful photograph, even if printed from a technically deficient negative, is always preferable to a dull and boring picture, no matter how technically perfect the negative from which it was derived. This fact, however, does not excuse a photographer from learning how to evaluate a negative in regard to technical excellence—an ability which is indispensable for two reasons:

1. Whenever possible, experienced photographers bracket their exposures, which means that they shoot several otherwise identical pictures of the same subject at slightly different *f*/stops or shutter speeds in order to make sure that they will get at least one perfect negative. In black-and-white photography, the difference between such consecutive exposures should be equivalent to two *f*/stops. (The exposure latitude of modern black-and-white films is so great that smaller variations would be wasteful; larger ones might result in missing the best exposure.) In photography of subjects of average contrast, a bracket consisting of three exposures is usually sufficient; the first one should be made in accordance with the data furnished by an exposure meter, the second four times as long (open up the diaphragm two stops), and the third one-quarter as long as the first (close the diaphragm aperture two stops relative to the first exposure). If subjects of more than average contrast are involved, shooting a bracket of four or five different exposures may be advisable. After the film has been developed, the photographer selects the best negative of the series for printing. To be able to do this, he must, of course, know how to evaluate a negative.

2. Even if there is no choice among negatives, a photographer must know how to read the negative correctly in order to be able to select a paper of suitable gradation (see Volume II) and produce a satisfactory print without undue waste through faulty exposure. For this, he must also know how to evaluate a negative.

To evaluate a negative, a photographer must judge it in regard to the five main qualities already discussed (pp. 59–66): sharpness, density, contrast, graininess, and cleanliness. In addition, he should consider the following:

Relationship between density and contrast

Density and contrast are two different, independent negative qualities which can, however, combine in such a way that it may be very difficult to ascertain which is which. Add to this the fact that density is affected by film exposure and film development, and contrast by subject contrast and film development, and it should be clear that at times it can become extremely difficult to pin down the source of a specific effect or error. For example, a negative is too dense, either because it was overexposed, or because it was overdeveloped. And it is, of course, also possible to *both* overexpose *and* overdevelop a film, in which case the negative density would be extreme. Such an almost uniformly black negative might seem entirely hopeless as far as yielding a decent print is concerned (and therefore totally undesirable), but it can, paradoxical as this may sound, actually be preferable to a much thinner and apparently better negative. This would be the case if a photographer had seriously overexposed his film, perhaps because he forgot to change the shutter speed or stop down the lens when switching from dimly lit indoor to bright outdoor shots. Now, overexposure, which increases the density of the future negative, simultaneously lowers its contrast. Therefore, if our photographer would try to correct his exposure mistake by shortening the time of development (which would produce a thinner negative, but would reduce contrast), he would reduce the already insufficient contrast of the negative still further, perhaps to the point where not even the hardest paper would be contrasty enough to yield a satisfactory print.

The correct way to save a badly overexposed film is to deliberately overdevelop it because overdevelopment increases contrast. In other words, the contrast lost through overexposure must be regained through overdevelopment. Such a negative, of course, would appear almost entirely black, but this super-density can easily be brought back to normal through chemical reduction (p. 112). The result: a negative of normal contrast and density.

The above discussion should make it clear that exposure and development are related insofar as the effects of one can intensify or cancel the effects of the other. Therefore, as far as possible, development should be considered in terms of film exposure and film exposure in terms of subject contrast, as will be clear in a moment. I say "as far as possible" because, if under- and overexposed negatives occur side by side on the same roll of film together with correctly exposed ones, it is obviously impossible to save the bad ones through appropriate modification of development. But if an entire film strip is either over- or underexposed, or if sheet film is used, changes in the mode of development can sometimes save an otherwise botched job. In this respect, a photographer should know the following:

Correct exposure + Normal development = Negative of normal contrast and density

Correct exposure + Extended development = Negative of higher than normal contrast and density

Correct exposure + Shortened development = Negative of lower than normal contrast and density

Overexposure + Normal development = Negative of low contrast but higher than normal density

Overexposure + Extended development = Negative of normal contrast but extreme density

Overexposure + Shortened development = Negative of lower than normal contrast but normal density

Underexposure + Normal development = Negative of near-normal contrast but low density

Underexposure + Extended development = Negative of high contrast and near-normal density

Underexposure + Shortened development = Negative of low contrast and very low density

Unsharp negatives produce unsharp prints, and nothing can be done about it.

Dense negatives, as far as gradation is concerned, can be either normal, soft, or hard; but they are always more grainy and more difficult to print than negatives of normal density.

Thin negatives, as far as gradation is concerned, can be either normal, soft, or hard. They often yield prints deficient in shadow detail.

High-contrast negatives yield prints deficient in intermediate shades of gray.

Low-contrast negatives yield prints which easily appear "flat" and in which black and white normally do not occur together.

Grainy negatives produce grainy prints. If the gradation of the negative permits, the grain effect can be minimized by making the print on paper of soft gradation, maximized by printing on paper of hard gradation.

Dirty negatives yield dirty prints that can be saved only through spotting or retouching.

To reduce subject contrast in the print, expose generously, and slightly shorten the time of development. If necessary, print on paper of soft gradation.

To increase subject contrast in the print, expose on the short side, and considerably increase the time of development. If necessary, print on paper of hard gradation.

And here is an old rule which still holds good: In black-and-white photography, when in doubt and particularly if the subject is rather contrasty, *erring on the side of overexposure is preferable to underexposure.* Too much negative density can be dealt with, either through a corresponding increase in print exposure, or through chemical reduction of the negative (See p. 112). But not even the most accomplished developing technique can conjure up detail which, because of insufficient exposure, did not exist in the film.

FACTORS THAT AFFECT DEVELOPMENT

Once the film has been exposed, the battle for the perfect negative is half won—or half lost—since by then some negative qualities are unalterably fixed and others laid down in fundamental form. A negative is either sharp or unsharp (the lens was either correctly or incorrectly focused); perhaps it is blurred (the shutter speed may have been too slow to freeze the subject's motion or to offset accidental camera movement during the exposure); its basic density has been decided (the film was either correctly or incorrectly exposed); its basic gradation is fixed (because of the combined effect of subject contrast, film type, and exposure); its basic granularity has been determined (by type of film). Now, it is up to the photographer not to ruin through faulty development the good he has accomplished and, if possible, simultaneously to correct mistakes he might have made. This can be done through appropriate choice or modification of the following factors:

> **Type of developer**
> **Temperature of developer**
> **Time of development**
> **Activity of developer**
> **Mode of agitation**

Type of developer. The different types of developer and their characteristics and uses have already been discussed (p. 51). But let me repeat: Under normal conditions, using a developer that the film manufacturer recommends for his product is never wrong. If conditions are not normal, of course, circumstances and the intentions of the photographer may have to determine the choice: perhaps a tropical developer if it is impossible to keep solution temperatures from rising above normal; a high-energy developer if underexposure is suspected; a fine-grain developer if abnormally large prints have to be made from 35mm or smaller negatives; and so forth.

Temperature of developer. Like all chemical reactions, film development is influenced by temperature. Raising the developer temperature accelerates development, increases negative contrast and density, promotes graininess, and causes the film emulsion to swell and soften until eventually it begins to reticulate, melt, and float off its base. Conversely, lowering the developer temperature slows down the rate of development and causes the developer to act unpredictably until finally it ceases to act at all. Normal or standard temperature for all photographic processes is 68° F.

71

Time of development. In order to reduce the exposed silver halides to metallic silver, the developer must penetrate the film emulsion, a process that takes time. Development begins at the surface and gradually spreads to deeper levels, the developer converting more and more of the exposed silver crystals to metallic silver as time goes on, the image progressively gaining in strength. Where the negative is thin, in the shadows and dark areas of the subject, only the surface grains of the emulsion were light-struck. Development, of course, is completed sooner in these areas than in those where exposure to strong light also activated the deeper layers of silver salts. As a result, with continuing development the image not only gains in *density*, primarily in the heavily exposed areas, but also in *contrast*, since development of the shadow areas is completed relatively soon whereas the highlight areas continue for a long time to develop and gain in density. If a photographer interrupts this process too soon, he will get a negative that is too thin and contrastless to yield a usable print. Conversely, if he waits too long before he terminates development, he will get a negative that is too dense, too contrasty, and difficult, if not impossible, to print.

Activity of developer. Recommended developing times always apply to a specific developer of specific temperature and strength or activity. The strength of a developer depends on three factors: the nature of the active ingredients, the dilution of the developer solution, and the degree of exhaustion of the bath. Therefore, experienced photographers measure carefully when they prepare a developer or dilute a stock solution, keep track of the number of negatives already developed in a certain amount of solution, do not overuse the developer, add replenisher at the proper moment, and discard the solution before it is exhausted. They also know that aerial oxidation shortens the useful life of any developer and saps its strength (remember, storage bottles must always be kept filled right up to the top); that a used developer spoils faster than an unused one; and that the shelf life of even a stock solution in a stoppered bottle is not unlimited.

Mode of agitation. The purpose of agitation is to assure the production of evenly developed negatives by removing the byproducts of development from the surface of the emulsion and promoting a constant flow of fresh developer to all parts of the film. Increasing the rate of agitation increases the rate of development; excessive or insufficient agitation makes development unpredictable. Therefore, instructions published by manufacturers of films, developers, and developing tanks regarding the mode of agitation must be followed to the letter if suggested developing times (p. 73) are to have any meaning. Another important factor is the size of the tank. The smaller the tank (and therefore the amount of developer), the more critical the mode of agitation.

Since incorrect agitation during development is a common cause of streaky, mottled, and overly dense or thin negatives, photographers should pay attention to the following: The more mechanically uniform the mode of agitation, the worse the result since the currents always hit the same area in the same way, increasing agitation and therefore density along their paths. Conversely, the more random the mode of agitation, the better.

Insufficient agitation causes mottled or underdeveloped negatives. Excessive agitation, particularly vigorously pumping the reel up and down in the developer, in addition to overdeveloping, causes streaks of uneven density across the width of the film. In 35mm negatives, such treatment will cause longer or shorter streaks of alternating higher and lower density apparently emanating from the sprocket holes at right angles to the edge of the film. Too frequent or energetic rotation of the reel gives rise to streaks along the length of the film and may cause differences in the overall density of the negatives at the beginning and end of the roll due to differences in rotational speed.

The time-and-temperature method of film development

The interrelationship between the type, state of activity, degree of dilution, and temperature of a developer, the mode of agitation, and the duration of the development makes it obvious that predictable results can be achieved only if all these factors are carefully controlled. This is easier than it may sound since actually all the elements involved are known to the photographer except one: the duration of the development. However, since the time of development is directly related to the temperature of the developer, even this remaining factor can easily be ascertained by consulting the chart that film manufacturers include with their product. The following is a slightly simplified reprint of the chart that Kodak includes with its Tri-X Pan roll films and 35mm cartridges.

Developing times (min.)

Kodak packaged developer	Small tank, agitation at 30-sec. intervals					Large tank, agitation at 1-min. intervals				
	65°F.	68°F.	70°F.	72°F.	75°F.	65°F.	68°F.	70°F.	72°F.	75°F.
D-76	10	8	7	6	5	11	9	8	7	6
D-76 (1:1)	13	11	10	9	8	15	13	11	10	9
Microdol-X	13	11	10	9	8	15	13	11	10	9
DK-50 (1:1)	5½	5	—	4¾	4½	6½	6	5¾	5½	5

Provided the photographer uses the correct type of developer in the appropriate strength (either undiluted or diluted 1:1, *i.e.*, one part developer to one part water), makes sure it is fresh as far as its state of activity is concerned, and follows the mode of agitation indicated at the top of the chart, all he has to do is take the temperature of his developer, look up the corresponding time of development in the appropriate column, and proceed accordingly. Developing films on this basis is called *development by time and temperature*. It is, at least in my opinion, vastly superior to the method of developing by visual inspection, which became obsolete with the arrival of the first panchromatic film.

Experienced photographers may, of course, want to modify the time of development suggested by the film manufacturer in accordance with the contrast of the subject and the state of the exposure in order to increase or decrease the density or contrast of specific negatives. The principles that apply have already been stated on pp. 71–73. In practice, it is always preferable to make such adjustments in the time of development rather than in the temperature of the developer. The respective increases or decreases in developing time depend, of course, on the magnitude of the desired change in density or contrast relative to normal. Accurate predictions are impossible to make, but increases or decreases of up to 25 per cent relative to normal developing times should be sufficient for all but the most extreme cases. Experimentally inclined photographers are advised to make their own tests and compute their own charts which, once compiled, are valid forever.

PRACTICAL FILM DEVELOPMENT

No matter whether you develop a roll of 35mm film in a reel-type tank, half a dozen sheets of 4″ x 5″ film in a tray, 120 roll film by the "see-saw method," or sheet film in hangers in an open tank, the basic process and the steps involved are always the same. Whatever differences exist apply only to details like loading the tank with film or mode of agitation; these will be dealt with later and should present no problem. What is important is the following sequence of events:

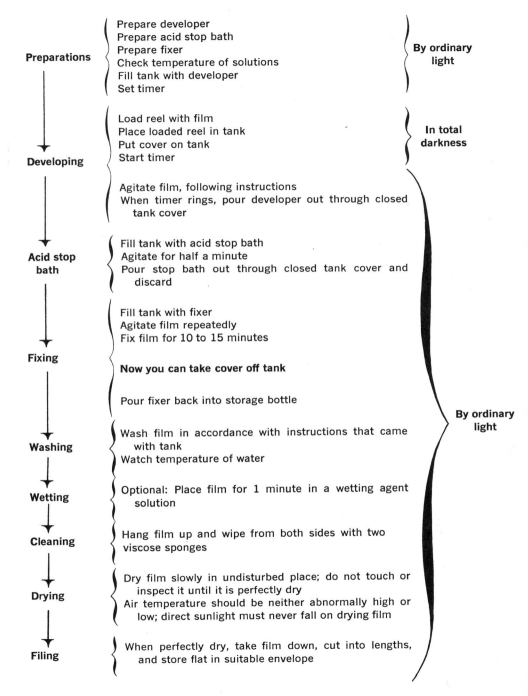

Preparations
Prepare developer
Prepare acid stop bath
Prepare fixer
Check temperature of solutions
Fill tank with developer
Set timer
} By ordinary light

Developing
Load reel with film
Place loaded reel in tank
Put cover on tank
Start timer
} In total darkness

Agitate film, following instructions
When timer rings, pour developer out through closed tank cover

Acid stop bath
Fill tank with acid stop bath
Agitate for half a minute
Pour stop bath out through closed tank cover and discard

Fixing
Fill tank with fixer
Agitate film repeatedly
Fix film for 10 to 15 minutes

Now you can take cover off tank

Pour fixer back into storage bottle

Washing
Wash film in accordance with instructions that came with tank
Watch temperature of water

Wetting
Optional: Place film for 1 minute in a wetting agent solution

Cleaning
Hang film up and wipe from both sides with two viscose sponges

Drying
Dry film slowly in undisturbed place; do not touch or inspect it until it is perfectly dry
Air temperature should be neither abnormally high or low; direct sunlight must never fall on drying film

Filing
When perfectly dry, take film down, cut into lengths, and store flat in suitable envelope

} By ordinary light

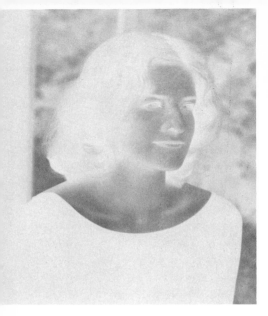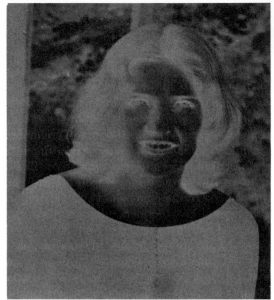

Density is equivalent to the lightness or darkness of a negative and has nothing to do with contrast. The negative *above, left*, for example, has too little density (is too thin) to print well but shows relatively high contrast. On the other hand, the negative *at the right* has excessive density but very low contrast.

Contrast is equivalent to the difference between the lightest and the darkest areas of a negative and has nothing to do with density. The negative *below, left*, for example, has too little contrast (is too flat) to print well but almost normal density, while the negative *below, right*, is excessively contrasty yet combines areas of very low and very high density.

Preparations

If you have never before loaded a reel-type tank with film, I suggest you sacrifice an unexposed roll (better still, when you buy the developing tank, ask your dealer to give you a free roll of outdated film), and practice loading the reel in accordance with the tank manufacturer's instructions, first in daylight, then in darkness, until you have the knack. Loading a reel with film is a potentially hazardous operation: If the reel is even slightly wet, the film cannot slip smoothly into the grooves but will sooner or later jam with probably disastrous consequences. Therefore, before you start loading, make sure that the reel is perfectly dry. The other danger is from finger marks; be sure your hands and fingers are dry, hold the film by the edges only, and do not let your fingers come in contact with the emulsion side.

Since you will have to load the tank with film in darkness, arrange everything you may need so that you can find it without fumbling: the film roll or cartridge to be developed, the hook-opener to pry the top off the 35mm cartridge, the developing tank, the film reel, the tank cover, and the pre-set timer, which has to be started the moment the film is immersed in the developer.

Prepare developer (p. 50). Partly fill a large vessel with lukewarm water. Check the temperature with your darkroom thermometer (p. 47); then add cold water until the temperature is down to 68° F. and remains stable. In accordance with the instructions accompanying the developer, pour the required amount of water into a graduate; then add the developer powder and stir gently with your stirring rod until it is completely dissolved. If you use a prepared liquid developer, dilute the stock solution in accordance with the instructions on the label.

A developer solution that has been used must be filtered before it can be used again to remove sludge, particles of emulsion, and other impurities that otherwise might settle on the film, causing spots. This is easily accomplished by pouring the developer into a bottle via a funnel that has been loosely stoppered with a wad of absorbent cotton. Solutions that are colder than approximately 65° F. must be warmed first, since, at lower temperatures, some of their components might have crystallized. Filtration would remove these crystals from the developer and thereby spoil it.

Prepare acid stop bath (p. 54). Its temperature must be the same as that of the developer. If temperatures are relatively high (highest normally permissible processing temperature is 75° F.), use of the following hardening stop bath is recommended: Dissolve 30 g of granulated potassium chrome alum in 30cc of a 5% solution of sulphuric acid, then add water to make one liter.

Prepare fixer (p. 54). Its temperature should be more or less the same as that of the developer. If you use a prepared fixer, read—and follow—the instructions for preparing the bath, which, if prepared incorrectly, might spoil immediately.

If you use large quantities of fixer, self-mixing may be advisable since it is simple and can save you money. Here is a proven formula (Kodak Fixing Bath F-5):

Water (about 125°F. or 50°C.)	80 oz.	or	600cc
Kodak sodium thiosulfate (hypo)	2 lb.	or	240 g
Kodak sodium sulfite, desiccated	2 oz.	or	15 g
Kodak 28% acetic acid	6 oz.	or	48cc
Kodak boric acid, crystals	1 oz.	or	7½ g
Kodak potassium alum	2 oz.	or	15 g
Cold water to make	1 gal.	or	1 liter

Dissolve the sodium sulfite first, then add the acids, then the potassium alum. Do not mix the alum directly with the sodium sulfite because this would result in the formation of aluminum sulfite and the precipitation of a white sludge. Dissolve the sodium thiosulfate separately in 125° F. water, then let it cool down to 85° F. before adding it to the sulfite-acid-alum solution. Acetic acid is sensitive to heat, and if added to the 125° F. hypo solution would decompose the hypo, turn the bath milky, and ruin it.

Provided an acid stop bath (p. 54) is used, the capacity of this fixer per gallon is approximately 100 rolls of 35mm film (36 exposures) or 100 rolls of 120 film. The life of the stock solution in a stoppered bottle is approximately two months, that of the working solution in a deep tray or tank one month, and in a shallow tray one week.

Check temperature of all processing solutions; it should not be below 65° F. or above 75° F. However, the only really critical temperature is that of the developer, which must be known with an accuracy of ±1° F., since it determines the duration of the development (p. 73). The temperature of the acid stop bath should be the same as that of the developer. The temperature of the fixer should be within a few degrees of that of the stop bath, and that of the water can be anywhere between 60° F. and 80° F.

Processing solutions that are too warm or too cold can be brought to the proper temperature as follows: To cool a solution, place the bottle in a deep bowl filled with crushed ice, or immerse in the solution a plastic bag filled with ice; do not put the ice directly into the solution—this would dilute and spoil it. To warm up a solution, place the bottle in a deep bowl filled with hot tap water. In either case, keep checking the temperature with a thermometer *until it is uniform throughout and stable.*

If the darkroom temperature is more than 5° F. higher or lower than the required solution temperature, achieving this temperature may be easy, but maintaining it for any length of time may pose a problem. In such cases, placing the solution-filled tank or tray (for sheet film or see-saw roll-film development) in a larger bowl or tray filled with water of the proper temperature provides a cushion which should make it possible to maintain the desired temperature for the duration of development. Occasional thermometer checks of this water bath and periodically adding hot or cold water may be necessary to maintain the processing solution at the desired temperature.

Note in this connection that metal tanks and trays are good conductors of heat which quickly transmit the temperature of the surrounding water bath to the processing solution inside. Plastic, on the other hand, has poor heat conductivity and responds to changes in temperature only slowly but— and this is an advantage—keeps the solution inside the container at the same temperature level for a longer time than metal.

Fill the tank with developer (p. 51) and make sure that the solution level is neither too high nor too low. In the first case, the tank would overflow when you immerse the film reel; in the second case, a strip along the upper edge of the film would develop only incompletely and your negatives would show developing streaks.

I am aware of the fact that many photographers place the loaded reel in the dry tank and pour the developer into the tank *after* it has been closed (provided, of course, construction of the tank cover permits this). I strongly advise against this practice because filling the tank through the light-proof opening in the cover is a slow process, and before the entire film is covered by the developer, the bottom part had a headstart which, if the required time of development is relatively short, may result in unevenly developed negatives.

Set the timer in accordance with the type of film, the type and temperature of the developer (p. 73), and the desired density and contrast of the resulting negatives (p. 68). You can get all the necessary data by consulting the chart of developing times which film manufacturers include with their films, an example of which is reprinted on p. 73.

Developing

The factors that determine success or failure of film development are: selection of the most suitable *type of developer* (p. 51); the *temperature* of the developer (p. 71), which must not be lower than 65° F. and should not be higher than 75° F. (normal developer temperature is 68° F.); the *time of development* (pp. 72 and 73), which is determined by the temperature of the developer; the *activity* of the developer (p. 72); and the *mode*

of agitation (p. 72) of the developing films. These factors apply regardless of the type of negative material, the design of the processing equipment, or the particular technique. Specific instructions for the different methods of film development are given on pp. 82–89.

Acid stop bath

The nature and purpose of a stop bath have been explained on p. 54. Although not strictly a necessity, use of this bath is strongly recommended to all discriminating photographers. Rinsing films and papers between developer and fixer is only a poor substitute for an acid stop bath.

Fixing

The nature and purpose of fixing have been explained on p. 54. A proven formula and instructions for self-mixing are given on p. 78. To prevent streaks and stains, immediately following their immersion in the hypo bath, films and papers must be agitated for 20 to 30 seconds; to assure proper fixation, agitation must be repeated periodically for the entire duration of the treatment. Particular care must be taken that films or prints do not stick together in the fixer for any length of time, especially right after immersion. The safest way of fixing films and prints is the two-bath system described on p. 55; however, for reasons given on p. 55, overfixation must be avoided. Exhausted fixers produce negatives and prints that are not permanent, even though films may appear clear. In prints, the clearing point cannot be seen; instead, use the fixing times the manufacturer recommends. The capacity of an average fixer is given on pp. 78, 131. The point of exhaustion of a fixing bath and an acid stop bath can be determined with the aid of the Kodak Testing Outfit for Print Stop Baths and Fixing Baths, or one of the test solutions made by other manufacturers of photographic supplies.

Hypo-neutralizer bath

The purpose of this bath has been explained on p. 56. Like the acid stop bath, it is not strictly necessary, but its use is strongly recommended to all photographers who are concerned about the permanency of their work.

Washing

The purpose of washing films and prints at the end of the processing cycle is to remove the remaining processing chemicals and dissolved silver

compounds from the emulsion and paper base; otherwise, these chemicals would slowly decompose, attack the image, and cause it to discolor and fade. The degree to which remaining chemicals can be removed depends on the following factors: *The degree of freshness of the fixer*—a fixing bath nearing exhaustion no longer converts all the unexposed silver salts into water-soluble compounds (p. 131). *The rate of water-flow*—if sufficiently rapid to effect a complete change of water in the washing vessel once every five minutes, films should be reasonably well washed within 20 to 30 minutes and prints after one hour. (If a hypo-neutralizer bath is used, washing films for five minutes is sufficient for normal purposes.) *The temperature of the wash water*—washing efficiency decreases rapidly with decreases in temperature and is very low below 60° F. *The design of the washing vessel*—since hypo is heavier than water, it sinks to the bottom of the tank or tray, which should be drained accordingly. Trying to wash films or prints by placing them in a tray or tank under a running faucet (with the water draining over the rim of the vessel) is totally inefficient and merely leaves them to soak in their own hypo. Improving this method by removing the hypo-laden water from the bottom of the container with the aid of a syphon-device or a standpipe is effective only if films or papers can be prevented from sticking together by frequent agitation. A good method is to wash negatives or prints suspended from cork clips (p. 42) floating in a large tank. The effectiveness of any washing method can be increased considerably (and the washing time shortened) by treating films and papers prior to washing in Kodak Hypo Clearing Agent (p. 56) and/or Kodak Hypo Eliminator HE-1. (Consult the manufacturer's instructions.)

Wetting agent bath

The purpose of this bath has been explained on p. 56. Like the acid stop bath and the hypo neutralizer bath, its use is not necessary, but it is a precaution that concerned photographers take to improve the quality of their work.

Cleaning

Cleanliness, as emphasized repeatedly, is one of the prime requisites for satisfactory darkroom work. The correct way of cleaning negatives prior to drying will be discussed on p. 84, the effects of lack of cleanliness and care on p. 103. Casual photographers who regard the cleaning of negatives prior to drying or enlarging as a useless chore, are reminded that correcting the effects of this evidence of lack of care, as far as this can be

done at all, is a still greater chore: spotting (see Volume II) and retouching a print take many times as long as properly cleaning a negative, not to mention the fact that the visible traces of such corrective measures are almost impossible to hide. And if many prints have to be made from one dirty negative, spotting them may take hours, whereas it would have taken only seconds to properly clean the negative.

Drying

Negatives should be dried in a place that fulfills two conditions. First, *the air must be free of dust.* In practice, this means a quiet place where whatever dust is present has settled and is not disturbed again by air currents (open windows or doors, air-conditioning) or people. Second, *conditions must be uniform during the entire period of drying.* From the moment the negatives have been hung up wet to the moment they are taken down dry, they must not be disturbed by handling (such as checking whether they are already dry or how well they came out), must not be moved to another place, and must not be exposed to sudden drafts (opening a door or window) or the sun, which might cast a moving shadow across the films, warming them unevenly and causing plus-density streaks resulting from the different rates of drying.

Trying to shorten the time of drying with a fan is an invitation to disaster because it would cause dust particles to be propelled at high speed onto the emulsion. Inexpert handling of half-dry films leaves indelible fingermarks even when the fingers are dry. Roll film curls and snakes as it dries; to prevent neighboring films from touching and possibly scratching or sticking to one another, space them sufficiently far apart and weigh their lower ends with film clips. Changes in the rate of drying causes streakiness, the part of the film that dried faster than the rest having a different density.

Roll-film development in a reel tank

Read the general instructions given on pp. 77–82, all of which apply; then supplement them with the following:

Check once more that all solutions are ready and at the proper temperature; that the timer is set for the applicable developing time *minus 30 seconds* to make allowance later for the time it takes to drain the developer from the tank; and that the tank, reel, cover, lid lifter, and film magazine or roll of film are arranged on the dry bench in such a way that you can easily find each item in the dark.

Turn off the room light and proceed in total darkness.

Open the 35mm magazine by holding it with the long end of the spool down. Then pry the cap off with a lid lifter or a hook-type bottle opener, and take out the spool with the film. *If you develop roll film,* break the paper seal, unroll the paper backing, and let the film curl up into a roll. Cut a 35mm film off its takeup spool; alternatively, tear a roll film off its paper backing and discard both paper and spool. Cut the tape together with the last quarter inch of the film off the roll with the scissors, otherwise, it may cause trouble later by sticking when you feed the film into the reel.

Load the reel with film in accordance with the tank manufacturer's instructions. As an added precaution, to prevent the film from slipping partly out of the reel during agitation, some photographers fold the last quarter inch of film sharply back on itself and wedge it into the spiral grooves where it acts as a brake. While loading, hold the film by the edges only. Be careful not to touch the emulsion side (the inside of the curl), although you may gently touch the outside of the roll when guiding and feeding the film into the channels of the reel. Your hands, needless to say, must be dry and clean.

Slowly lower the loaded reel into the tank filled with developer. Keep the reel completely immersed, gently tap it a few times on the bottom of the tank to dislodge possible air bells, then put the cover on the tank.

Start the timer immediately.

Turn on the white light, or take tank and timer out of the loading closet or changing bag (p. 27). From now on, processing continues by ordinary light.

Agitate the film. If construction of the tank and its cover permits turning the tank upside down, after the film has been immersed for half a minute, invert the tank completely five times at a rate of one turn per second. Repeat this at half-minute intervals throughout the entire period of development.

If the tank cannot be inverted, after the film has been immersed for half a minute, agitate by sliding the tank back and forth over a distance of approximately ten inches, pushing for five seconds at a rate of two cycles per second. Simultaneously, by gripping the tank from above, rotate it back and forth through half a turn. Repeat this at half-minute intervals throughout the entire period of development.

When the timer rings, pour out the developer through the closed tank cover.

Pour the acid stop bath (p. 54) into the tank, and agitate continuously for half a minute, then drain and discard the bath. If you use a water rinse instead of a stop bath, fill the tank repeatedly with fresh water, then drain it.

Pour the fixer (p. 54) into the tank and immediately agitate for half a minute in the manner described before. Repeat this four or five times dur-

ing fixation. Drain the tank, and pour the fixer back into its bottle. It should be filtered before it is used again.

Remove the cover and fill the tank with water, rinse the film by dipping the reel up and down a few times, then pour out the water.

Fill the open tank with hypo-neutralizer (p. 56), agitate by gently dipping the reel up and down a few times, then drain the tank and discard the solution.

Leaving the film on the reel in the open tank, wash (p. 80) for 30 minutes under running water, which should not be colder than 60° F. To improve circulation, place a spacer under the reel and lift it approximately a quarter of an inch off the bottom. Direct the stream of water right into the core of the reel, and adjust the rate of flow so that the water passes through the core of the reel, up through the coils of the film, and out over the edge of the tank. To assure adequate washing, drain the tank every five minutes until washing is completed.

Immerse film and reel for half a minute in a wetting agent bath (p. 56).

Pull the film out of the reel, and hang it up to dry.

Clean the film from both sides with a damp viscose sponge (p. 49). Some photographers simplify the cleaning process by dipping their hand in the wetting agent bath, then slowly pulling the film strip between their stiffly held index and middle fingers, wiping off surface moisture, loose emulsion particles, and foreign matter.

When the film is dry, take it down and prepare it for printing. Roll films (2¼″ x 2¼″ negatives) are customarily cut into lengths of either three or four frames per strip, 35mm films into lengths of six or seven frames. Don't make the mistake of cutting the strips too short or, worse, into separate negatives, an amateurish practice that makes handling and filing extremely awkward.

Store negatives only in suitable envelopes or sleeves. Normally, 35mm and roll-film negatives should be filed not rolled but flat. More specific instructions are given on p. 92.

NOTE: Some photographers, instead of completing the entire film developing process in the same tank, as soon as the developing phase is completed, take the reel and film out of the tank and continue processing in separate open tanks or vessels, each containing one specific processing solution. This method is somewhat faster than ordinary tank development, particularly when a larger number of films has to be processed at one time. It also allows for more precise control through more accurate timing and avoids the danger of contaminating the developing tank with other solutions. On the other hand, a major part of the work must be done in total

darkness because the white light cannot be turned on until the last film has been in the hypo for two minutes.

Roll-film tray development

This technique, also known as the "see-saw method," has two advantages over tank-and-reel development. It does not require a developing tank; and development is likely to be more even, which will be appreciated especially if the negatives contain large areas of medium gray where streakiness is particularly noticeable. On the other hand, a major part of the process, from the moment the magazine or film roll is about to be opened to the time the film has cleared in the fixer, takes place in total darkness.

Preparations. In addition to the preparations described on pp. 77–79 (except, of course, filling a film tank with developer), five individual trays must be set up in a row for water, developer, acid stop bath, fixer, and hypo-neutralizer. Except for the developer tray, which should be smaller (4″ x 5″ or 5″ x 7″ is just right), the trays and solutions normally used for paper processing will do. Some photographers place the developer tray on a folded towel for positive identification in the dark by feeling. Trays should be spaced three or four inches apart with the water tray at the far left followed by the developer tray. Also, two film clips should be placed within easy reach on the table.

Set the timer in accordance with the required developing time, but this time do *not* subtract 30 seconds as during tank-and-reel development, since there will be no time lag at the end of the developing phase.

Turn off the light and proceed in total darkness.

Break the seal of the film roll and unroll the paper backing until you get to the film; then attach a film clip to its end. Hang the clip on a hook or nail about six feet from the floor, then carefully unroll the film under slight tension to prevent it from twisting. When you come to the end, cut the film off the backing paper, drop the paper, and fasten a second film clip to the lower end of the film.

Take the first clip off the hook and hold it in your left hand; then grab the second clip with your right hand, keeping the film taut all the while to prevent it from twisting. This is the only awkward moment during the entire procedure. If the film is stretched too much, it may slip out of the clip; if given too much slack, it may twist and coil. Subsequently, with the *emulsion side down* (this is the inside of the coil), allow the film strip to

sag in the form of a U, but be careful not to give it a chance to twist. Slowly lower the bottom of the U into the water tray; then pass the film through the water by raising one hand while simultaneously lowering the other, in a rhythmic, see-saw motion. Keep this up for 10 to 20 seconds to wet the film thoroughly. Once it is good and wet, it will go limp and lose its tendency to twist.

Start the timer. Since the see-saw motion during development is equivalent to continuous agitation, shorten the applicable time suggested for tank-and-reel development by ten per cent.

Turn the film strip inside out so that its emulsion now faces up and promptly lower it into the developer. Pass it through the solution with the same see-saw motion for the entire duration of the development.

When the timer rings, transfer the film from the developer to the acid stop bath tray (p. 54), passing it through the solution in see-saw motion for 10 to 15 seconds.

Subsequently, transfer the film to the fixer (p. 54), which should be contained in a deep tray. After passing the film through the fixer for two minutes, you can *turn on the white light.* Arrange the film in big loops in the fixer but leave the film clips in place to prevent the strip from curling into a tight roll, its sharp corners digging into the emulsion. Periodically move the film around in the fixer to insure even and adequate fixation.

When fixation is complete, briefly rinse the film in water, transfer it to the hypo-neutralizer (p. 56) for half a minute, then wash and dry as described before (pp. 80–82).

Sheet-film development in a deep tank

This method is the most practical when more than six sheets of film have to be developed at the same time. The entire process, from the loading of film hangers to the time when the films have cleared in the fixer, takes place in total darkness. The remaining operations can be undertaken by white light.

Preparations. In addition to the preparations described on pp. 77–79, five separate, deep sheet-film developing tanks must be set up for developer, acid stop bath, fixer, hypo-neutralizer, and water. These tanks should be turned in such a way that the films are parallel to the front edge of the sink or wet bench. Each sheet of film is held in a stainless steel hanger, and the hangers are preferably (but not necessarily) gathered in a stainless steel developing rack. If you do not have such a rack, in the interest of uniform development, the hangers must be separated from one another in the tank by not less than half an inch.

To avoid confusion in the dark, all the paraphernalia must be arranged in an orderly pattern. Stack the holders containing the exposed films upright against the wall. Empty film hangers should hang on a special stand or wall brackets within easy reach of the operator. Loaded hangers should be placed in the developing rack.

If you have never loaded sheet-film hangers before, I suggest you practice loading in daylight with a developed sheet of film. Hold the hanger in your left hand, and spring back the hinged channel at the top. Pick up the film with your right hand, emulsion side* up, holding it by the top edge only and letting its back side rest on the fingertips of your right hand. Slide the film into the channels of the hanger until it hits bottom, then spring the hinged top channel back into place. Alternately, you can open the top channel, insert most of the left edge of the film into the lefthand channel, then slightly curve the film so that its righthand edge can snap into the righthand channel. Subsequently, push the film all the way to the bottom, then close the top channel. Give the hanger a quick shake to make sure that the film can move freely in the channels and has neither been buckled nor pinched.

Turn off the light and proceed in total darkness.

Load the hangers with film, placing the loaded hangers in the developing rack at your side.

Start the timer, take the loaded rack, and smoothly and carefully lower it into the developer tank. To dislodge possible air bells, sharply rap the hangers two or three times against the top edge of the tank; then let the films rest undisturbed for about one minute.

Agitate by lifting the entire rack completely out of the tank and immediately rotate it about 90 degrees by lowering one hand while simultaneously raising the other, either clockwise or counterclockwise, but always keeping the plane of the films parallel to the front edge of the wet bench. Quickly reimmerse the rack, then lift it again and repeat the rotating motion, this time in the opposite direction. Make sure that the films are rotated not much less than 90 degrees and that the run-off developer drains back into the tank. The entire operation should be performed rapidly and take no longer than five to seven seconds. Repeat the cycle at one-minute intervals until development is completed.

*The emulsion side of any film is dull, the back side shiny. The emulsion side of 35mm and roll film is always on the inside of the curl. To find the emulsion side of sheet film in the dark by feeling, slide your index finger along the short edge of the film until you locate the code notch (the identification mark which is different for different types of sheet film). Now, if you hold the sheet of film in vertical position so that *the code notch is in the upper righthand corner, the emulsion faces you.*

When the timer rings, lift rack and hangers out of the tank, let the films drain for a few seconds, and transfer the unit to the tank filled with the acid stop bath. Agitate by lifting and reimmersing the rack several times, then transfer it to the fixer tank. Fix for the appropriate duration, agitating frequently by raising and lowering the rack, then transfer it to the hypo-neutralizer and finally the water tank. Wash for half an hour under running water, changing the water five times by emptying and refilling the tank. Clean and dry films as usual.

Sheet film development in a tray

This method is capable of producing excellent results when not more than six sheets of film have to be developed together. An advantage over development in deep tanks is that it requires no expensive equipment since developing, fixing, and so on take place in ordinary trays. Furthermore, there is no danger of streaky development because of developer turbulence around the channel perforation of the hangers. On the other hand, to prevent damage to the film emulsion, extra careful handling of the developing films is required. Fingernails must be very short to prevent digs. The developer temperature (p. 71) should be on the low rather than the high side to avoid undue swelling of the emulsion. Highly alkaline developers should not be used to prevent excessive softening of the gelatin.

Preparations. In addition to the preparations described on pp. 77–79, five separate trays must be set up for water, developer, acid stop bath, fixer, and hypo-neutralizer bath. These trays should be only slightly larger than the film size that is to be processed; for 4″ x 5″ films, I find 5″ x 7″ trays most convenient. If you place the trays with their *short* sides parallel to the front edge of the wet bench or sink and place the developing films with their *long* sides turned toward you, undue lateral movement of the films, a frequent source of scratches, can be avoided. Solution temperatures should not exceed 72° F. to prevent the film emulsion from swelling and softening excessively. Stack the loaded film holders at your left, their long sides parallel with the front edge of the dry bench, so that you can pull the slide with your left hand and remove the film with your right.

<p align="center">**Turn off the light and proceed in total darkness.**</p>

Unload the film holders and place the exposed films, emulsion side up, on top of one another but slightly fanned (the way one holds a hand of cards); this way, you can subsequently take them more easily one at a time when immersing them in water.

88

Immerse the exposed films, emulsion side up, one at a time in a tray of water. Make sure that each film is completely covered with water before you place the next one on top of it; otherwise, they stick together and are difficult to separate without damage to the emulsion. When the last film has been dunked, gently and holding it by the edges only, draw the first film from the bottom of the stack and place it on top, being careful not to let one of its sharp corners dig into the emulsion of the film below. This is most easily accomplished by holding the film at a 45-degree angle to the surface of the water, placing its long edge against the near inner edge of the tray. Then let the film gently fall down on the water and dunk it. Repeat this with the rest of the films until the entire stack has been leafed through twice.

Start the timer.

Transfer the films as quickly as safely possible to the developer tray, drawing them one at a time from the bottom of the pile. Continue leafing through the stack of films and transferring them from the bottom to the top throughout the entire period of development, turning them occasionally end for end as you place them on top of the stack, but always with the emulsion side up.

When the timer rings, transfer the films one at a time to the acid stop bath tray (p. 54), then shuffle through the stack twice, pulling films from the bottom and placing them on top of the pile. Since the developer cannot be used again (because of the small volume involved, it will be exhausted), contamination of developer with stop bath solution is of no consequence here.

Transfer the films to the fixer (p. 54) in the same manner as before, and immediately go through the pile two or three times; repeat this process periodically until fixation is complete.

Transfer the fixed negatives one at the time to the hypo-neutralizer tray (p. 56). Repeat the shuffling process three times, then wash, clean, and dry the negatives in accordance with the previously given instructions (pp. 80–82).

CLEANING UP AFTER WORK

While your negatives or prints are washing, take time out for cleaning up your darkroom. Film developer that can be reused should be filtered (p. 57) before it is poured back into the storage bottle. However, do not try to save a film developer that is nearing exhaustion—time will finish it before it can be used again and the result will only be underdeveloped film. A developer that has been used for processing roll film by the see-saw method or sheet films in a tray is exhausted and should be dumped.

An indicator stop bath that still looks yellow can be used again; when its color begins to change to purple-blue, it is exhausted and should be dumped. An acetic acid stop bath (p. 54) should be prepared immediately before use; a used one should be discarded.

The condition of the fixer cannot be determined visually. If you suspect that it may be nearing exhaustion (p. 131), test it with one of the commercially available hypo test solutions (p. 135), and if the prognosis is poor, dump it down the drain. Fixer is expendable and cheap, but the consequences of working with an exhausted bath can be grave (p. 55).

To gauge the state of the hypo-neutralizer bath, keep track of what you put through it, then consult the label on the container, which states its capacity per gallon of solution.

Wash developing tanks, trays, graduates, funnel, stirring rod, thermometer, and so on under hot water. Store vessels upside down or on edge for proper drainage and drying.

Wash down the sink, paying particular attention to white hypo marks on the walls or splashboard behind the sink and on the floor. These spots not only look messy, but are a potential source of contamination of the entire darkroom with airborne hypo (p. 19). Wipe the sink dry with the darkroom sponge. Clean all sponges, including those used for cleaning films, by repeatedly wetting and squeezing them.

Careful workers make sure that their towels are clean. A dirty towel is a potential source of chemical contamination, resulting in spots or stains on negatives and prints. For safety's sake, treat yourself to a freshly laundered towel each time you develop or print.

Finally, before you close the darkroom door behind you, check that the safelights and other electrical equipment like print drier and mounting press are turned off.

THE PERMANENCE OF NEGATIVES AND PRINTS

Strange as it may sound, many photographers spend an awesome amount of money on cameras, lenses, and other photographic equipment, much love and care on taking pictures, and considerable time and effort on darkroom work; but they are careless, sloppy, and ignorant as far as the preservation of their work is concerned. Proof of this is readily available everywhere in fading negatives and prints, yellow with age, deteriorating at a rapid rate, just because their originators did not know better, or did not care. Anybody at all concerned about the permanency of his negatives and prints should heed the following advice.

Unfortunately, negatives and prints, being made of potentially unstable materials, are extremely sensitive to their environment. They are affected by time, temperature, humidity, chemical contamination, certain gases of the atmosphere, light and other forms of radiation, and by handling. They may fade, stain, tarnish, discolor, grow fungus, and be attacked by insects and gases. The dyes of color transparencies and color prints may fade, change color, or bleed. The bases of film and paper may become degraded, deteriorate, and affect the images which they support. Even the enclosures intended to protect negatives and prints may contribute to their undoing.

Negative permanence (as far as one can speak of permanence since, of course, nothing is really permanent) starts with proper processing. Use the two-bath fixing system described on p. 55, making sure that the fixer is correctly prepared, the negatives properly agitated, and the solution not overworked. Using the two-bath system and two one-gallon deep trays or tanks, no more than 100 rolls of film should be run through the fixer before the first bath is dumped, the second bath moved into its place, and a fresh second bath prepared. Under these conditions, leave the films in the first bath until they are clear, which should take no longer than one or two minutes; then transfer them to the second bath, and fix for another two or three minutes.

Following fixation the negatives should be rinsed briefly and then transferred to a hypo-neutralizer (p. 56) like Kodak Hypo Clearing Agent, Heico Perma-Wash, or FR Hypo Neutralizer where they should be treated in accordance with the respective instructions. These solutions are inexpensive, and careful workers use them only once.

The most effective method of washing roll film is by forcing water through the core of a plastic reel (p. 84) or with the aid of a washer that sends a stream of water through a stack of metal spiral reels. Provided the

rate of flow is sufficient to achieve a complete water change every four or five minutes and the water temperature is between 68° and 75° F., a 15- to 20-minute wash will produce negatives of archival quality.

Roll films should be cut into sections (p. 84) and stored flat. All negatives should be protected by envelopes made of a suitable material, each negative in its own sleeve to avoid the risk of films sticking together or forming silver stain in case they have to be stored for any length of time under conditions of considerable humidity. Glassine envelopes, ordinary plastic and PVC bags, and envelopes made of brown Kraft paper contain residual chemicals that attack the silver image and are unacceptable for archival storage. Best are high-quality white envelopes that have the seam at the side instead of in the middle. (Good quality envelopes of a material called Permalife are made by the Hollinger Corp., 3810 S. Four Mile Run Drive, Arlington, Va. 22206.) An excellent and very practical method of storing negatives is by means of the chemically inert, clear polyethylene Negative Preservers made by Print-File, Inc., Box 100, Schenectady, N. Y. 12304, which are available for 35mm films, 120 roll film, and 4″ x 5″ negatives. (Since few photo stores carry them, write directly to the manufacturer for descriptive literature.) Each preserver holds either all the negatives from a complete roll, or four 4″ x 5″ negatives, has the advantage over other negative filing systems that negatives are instantly visible together, and can be contact-printed without being removed from their sleeves.

The sleeved negatives must, of course, be stored in a place that is dry, cool, dark, and protected from harmful gases and airborne contamination. In places where air pollution is a problem, good containers for storing negatives are the large, air-tight army ammunition boxes sold by certain Army–Navy surplus stores.

To arrest further deterioration of improperly processed negatives—easily recognized by a more or less uniform yellow stain—proceed as follows:

1. Soak the negatives for about 20 minutes in plain water at a temperature between 68° and 72° F.

2. Refix the negatives for five minutes in a freshly prepared ammonium thiosulfate fixing bath diluted for films (for example, Kodak Rapid Fixer), agitating all the time.

3. If the yellow stain is heavy, add one ounce of Kodak Citric Acid crystals to one quart of fresh diluted fixer solution, and treat the negatives in this bath until the stain has disappeared. Unfortunately, with prolonged

treatment, this fixer–citric acid formula will also attack the silver image. Therefore, in cases of thin negatives, and in all cases in which the yellow stain is not so pronounced as to be objectionable, it is advisable to confine the restoration process to refixing as outlined under Step 2.

4. Rinse the fixed negatives briefly, then treat them in a hypo-neutralizer solution (p. 56), such as Kodak Hypo Clearing Agent or Heico Perma-Wash, in accordance with the respective instructions.

5. Wash the negatives for 15 to 20 minutes under running water at a temperature of 68° to 72° F.

6. Treat the washed negatives briefly in a wetting agent solution (p. 56); then wipe clean and dry as usual (p. 82).

V. How to avoid mistakes

Throughout this book, I have tried to advise the reader how he can avoid mistakes. At this point, I wish to add a few observations about photographic mistakes in general.

In photography, a mistake can be a blessing in disguise, provided, of course, the photographer is aware of it and is sufficiently interested in his work to find the underlying cause. Once a photographer has made a certain mistake, recognized its cause, and learned how to avoid it, he never has to make the same mistake again. In this sense, the man who made all the mistakes in the book ought to be an accomplished craftsman, each mistake having provided him with an experience that added to his knowledge, a milestone on the road to perfection.

Modern photographic films, papers, and chemicals are for the most part of such high quality that failures caused by manufacturing defects are very rare indeed—provided, of course, one sticks to reputable brands. Out of hundreds of faulty negatives and prints that have been brought to my attention, only a handful of the problems were due to defects in manufacturing. In all other instances, the photographer was to blame and could easily have avoided his mistake if he had paid more attention to the instructions. Consequently, perhaps the best advice for avoiding mistakes is this:

Carefully read and follow the instructions that accompany every piece of photographic equipment, package of photographic film and paper, or can and bottle of chemicals.

Before you blame disappointing results on the manufacturer of your photographic equipment or material, retrace your steps and make a real effort to find out whether you did something wrong. The chances are overwhelming that you did. If you are really stymied, Kodak provides a service for users of its products that might be able to help you. Send the puzzling negatives and prints together with an explanatory letter to the following address:

Sales Service Division
Eastman Kodak Company
Rochester, N. Y. 14650

An authoritative reply will follow; there is no obligation on your part, nor will there be a charge.

While most people try to forget their mistakes, smart photographers remember theirs, and a few even go so far as to preserve them. Instead of relegating them to the garbage can, they save faulty but interesting and potentially informative negatives and prints, and file them together with their explanatory data for future reference. In this way, they gradually build up a priceless reference library of unpleasantnesses to avoid and methods to avoid them. After all, they paid for these mistakes not only with their money, but also in terms of time, work, and disappointment; they may as well reap the benefits. Therefore;

**Save photographic mistakes for future reference
so that you and others can profit by them.**

Unfortunately, in photography, most mistakes are final; few can be corrected, and many of these only incompletely. Consequently, another good rule to remember is this:

**Avoiding photographic mistakes is simpler and cheaper
and pays off in the form of better pictures than trying
to correct them.**

While accidents can and will happen, the vast majority of photographic mistakes are caused by one of three factors:

**Carelessness,
Forgetfulness,
False economy.**

Carelessness manifests itself in many different forms, the most common ones of which are: *fingermarks on negatives and prints* (in the latter case caused by handling photographic paper with wet or hypo-contaminated hands); *sand inside the camera* (the result of carelessness at the beach), causing scratches parallel to the edges of the film; *dust that got into the camera* and settled on the film prior to exposure, manifesting itself in the

form of *white* spots in the negative and *black* spots in the print; *dust that settled on the film after development,* showing up in the form of *white* spots on the print; *unlabelled bottles and containers,* leading to confusion and unnecessary mistakes; *chemicals stored carelessly in paper bags,* spoiling rapidly by taking up moisture from the air; *spilled hypo solution,* chemically contaminating the entire darkroom; *manipulating photographic paper in the processing solutions by hand* (instead of using print tongs), causing stained prints; *guessing the temperature of processing solutions or the time of development,* leading to over- or underdeveloped films; *fingernails that are too long,* scratching still wet films; and the *absence of apron or towel in a darkroom, or a dirty towel,* the infallible sign of a photographer who does not care.

Forgetfulness can have rather disastrous consequences, most of which occur when taking the picture: *forgetting to wind the film after each exposure* when working with a camera in which winding the film and cocking the shutter are not mechanically coupled, leading to double exposure; *forgetting to take off the lens cap*—result: no picture; *forgetting to pull the slide* when working with sheet film or film pack—result: ditto; *forgetting to change the ASA film speed setting of the camera or exposure meter* when switching to a faster or slower type of film—result: over- or underexposure; *forgetting to change focus when changing from long shot to close-up or vice versa*—result: unsharp picture; *forgetting to consider the filter factor when calculating the exposure*—result: underexposure; *forgetting to consider the close-up factor when determining a close-up exposure*—result: ditto; *forgetting to rewind 35mm film before opening the camera for unloading*—result: catastrophically fogged film; *forgetting to put away light-sensitive paper before turning on the white light in the darkroom*—result: loss of the entire paper stock; *forgetting to clean the negative prior to enlarging*—result: dirty prints.

False economy, instead of saving money, invariably leads to additional expenses, unnecessary waste, and avoidable disappointment; it manifests itself most often in the following forms: *expensive camera but no exposure meter,* resulting in faulty exposures and wasted film and opportunities; *trying to save by buying cheap no-name brands of photographic equipment, film, paper, or chemicals; overworking processing solutions* with resulting lowering of negative and print quality, increased danger of stain, and premature deterioration of the accomplished work; *working wtih insufficient quantities of processing solutions,* a common cause of streaks and stains in negatives and prints; and using a *cheap, colored, unsafe lightbulb,* instead of an appropriate safelight.

HOW TO IDENTIFY MISTAKES

Only mistakes whose cause is known can be avoided in the future. To be able to profit from his mistakes, a photographer must know what he did wrong. The following survey is an expanded recapitulation and at the same time a summary of things said elsewhere in this text.

Unsatisfactory density and gradation are the result of one or more of the following factors:

Negative too thin, contrast too low: If the shadows contain detail, the development was too short or the developer too cold, too much diluted, or exhausted. If there is no detail in the shadows, the film was underexposed.

Negative too thin, contrast normal: The subject was relatively contrasty, but the film was underdeveloped.

Negative too thin, contrast too high: The film was underexposed and overdeveloped, or a high-contrast subject was underexposed.

Negative too dense, contrast too low: If the edges of the film are clear, the cause was overexposure. If the edges are fogged (gray instead of clear), the film was fogged by white stray light in the darkroom or by too intense exposure to a safelight that was not truly safe, at least not at the distance it was used. Other possible causes are a developer that was too warm, or film was outdated or stored under unsuitable conditions.

Negative too dense, contrast normal: overexposure in combination with overdevelopment.

Negative too dense, contrast too high: The film was overdeveloped; the developer was too concentrated or contained too much alkali; or the developer temperature was too high.

Black marks—uneven density, streaks, smears, lines, and dots that were not present in the subject—can have the following causes:

Streaks, smears, or whisps of black fog, usually (but not necessarily) starting at the edge of the film and trailing off toward the center of the negative, are caused by stray light *before* the film was taken into the darkroom. Perhaps a roll film had not been wound tightly enough, the camera

had a light leak, or a film holder was defective. (See the illustrations on p. 104.)

More or less geometrical, dark or black, and often tonally graded figures in the form of circles, crescents, polygons, pie-shaped sectors, and so on, found only in photographs taken against the light or containing a strong light source within the picture area are not developing defects but manifestations of lens flare, or internal reflections within the lens. They can be avoided only if direct sunlight or light from a strong lamp or lamps is prevented from entering the lens, either with the aid of an adequate lens shade, or by interposing a suitable object between light source and camera, which casts a shadow over the lens without, of course, cutting off part of the picture.

Lighter or darker, often wavy streaks and bands in a negative are a sign of uneven film development due to inadequate or incorrect agitation (p. 101). In 35mm negatives, particularly common are short, alternating light and dark streaks corresponding to the sprocket holes, extending at right angles to the edges of the film. Complete avoidance of this kind of developing mark, which is particularly noticeable when it happens to fall on even tones of medium gray, is virtually impossible in certain types of reel tanks where agitation pumps developer through the sprocket holes at higher than average pressure. The only *sure* method of perfectly even development of 35mm films is in deep tanks with nitrogen-burst agitation. This is the method used by all good commercial photofinishers.

Marks resembling flashes of lightning, tiny starlike designs, or rows of small black dots or short wiggly lines are caused by discharges of static electricity. This fault occurs particularly often on dry, cold days and can be avoided only if the photographer winds and rewinds his film and pulls the paper tabs of filmpack very, very slowly. (See illustration on p. 109.)

Colored stains in black-and-white films

The negative appears uniformly reddish, purplish, or blue-green in transmitted light: incomplete removal of the anti-halo dye. To clear the negative, treat it briefly in a weak alkaline solution (water containing a few drops of ammonia, or a weak developer solution); then wash and dry as usual.

Dichroic fog: The negative appears blue-green in reflected and red or purple in transmitted light. This defect may be caused by either one of the following factors: exhausted developer; excessively prolonged development; developer temperature too high; fine-grain film developed in developer containing potassium thiocyanate; exhausted stop bath; fixer heavily contaminated with developer; exhausted fixer; or negative exposed prematurely to white light while in the fixer.

Yellow fog: The negative appears uniformly yellow in transmitted light. This fault can be caused by the same agents that cause dichroic fog. Yellow fog developing over a period of time in old, stored negatives is a sign of insufficient fixing and washing. For corrective measures see p. 92.

Miscellaneous negative defects

Dust or particles of emulsion dried on the film are the result of: neglecting to wipe films clean after hanging them up to dry; force-drying films with the aid of a fan, which only stirs up dust, which in turn becomes embedded in the emulsion; or leaving films to dry in a room where people go to and fro, stirring up dust. (See illustrations on p. 103.)

Pinpoint-like clear spots in the emulsion are caused either by fine dust particles that settled on the film in the camera prior to exposure or by chemical contamination (most likely fixer powder that settled on the drying films).

Larger, perfectly round, and usually clear spots in the negatives are due to air bubbles that adhered to the developing films.

More or less elliptical (less often roundish) spots, usually with a dark rim and a lighter center, are caused by drops of water that fell on a still damp (or dry) negative or remained on the film after it had been hung up to dry. (See illustrations on p. 100.)

Partial reversal of the negative image into a positive one (pseudosolarization) is caused by accidental exposure of the film to unsafe light during development—either stray white light, unsuitable safelight, or light from a safelight that was too close to the film.

Blistering of the emulsion is caused by a stop bath or a fixer that was excessively acid.

It is vitally important that a photographer learns how to "read" a negative correctly. To facilitate this, I show here and in the following pages many faults as they appear in the negative as well as the form in which they would manifest themselves in the print.

Carelessness caused the faults illustrated on this page. *Above:* Fingermarks. *Below:* Marks caused by water drops left to dry on the film.

Faulty agitation caused the unevenness of tone that characterizes these pictures. Specifically, note the streak running parallel to the left side of the photographs in the *top row*; the dark streaks seeming to emanate from the sprocket holes of the picture shown *at the right* which were caused by excessive agitation which pumped developer through the sprocket holes; and the streaks in the pictures *below* which are due to insufficient agitation.

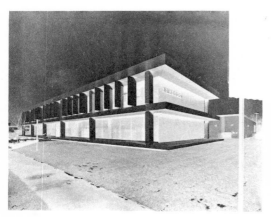

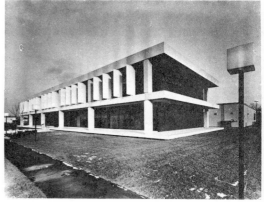

Unintentional double exposure ruined the film strip *at the left*. It was caused by a bad habit of many 35mm photographers who, when rewinding the film, leave the end sticking out of the cartridge. In this case, a mixup of exposed and unexposed cartridges caused the photographer to run the same roll twice, ruining in one fell swoop 72 pictures.

Static electricity left delicately branched tracings on the film strip *in the center*. Another example of "static marks" is shown on p. 109. How to avoid this nuisance is discussed on p. 98.

Stray light fogging the film strip *at the right* left its ruinous black marks on every negative. Its cause: careless loading of the camera in sunlight, roll film not wound tightly enough, or a light leak in the camera or bellows.

Dirt and scratches spoiled these shots. A single hair of lint that somehow got into the camera left its mark smack in the center of the picture (*top row*). Since this mark is *white in the negative* (and *black in the print*), it was caused by lint deposited on the film *before* the exposure. Lint settling on a negative *in the enlarger* leaves *white marks in the print.*

Fingernail digs in the wet emulsion leave marks like those shown *in the center row.*

A piece of grit or a trace of burr in the film-transport mechanism caused the wobbly scratch shown *below, left.*

Stray light was the cause of the phenomena illustrated on this page. Specifically: unwanted light reached the film because a filmpack was carelessly "squeezed" (*top row*); light penetrated inside a film holder because the corners of the slide were worn from overuse (*center*); light got inside the camera via a hole in the bellows (*bottom left*); and light found access to a sloppily wound roll of film (*below, right*).

Flare, examples of which are shown on this page, is caused by direct light entering the lens and reflecting from its internal surfaces onto the film. In the night shot *at the top*, it was the bright street lamp which produced the circle in the lower left corner of the negative; the black blob in the *center* picture is a flare due to shooting smack against the sun; and the "flying saucers" shown in the *bottom* row are lens flares caused by the brightly lit windows of the skyscraper.

Temperature, which was either too high or varied too much from one processing bath to the next, produced these disastrous effects. *Reticulation*, a softening and wrinkling of the emulsion, the effects of which are shown *above* and *below*, is caused by excessively high solution or wash-water temperatures or abrupt changes in temperature from one bath to the next. The effect of flames (*center*) is the result of a partial *melting* of the film emulsion due to excessively high wash-water temperature.

Faults of the negative not caused by faulty development. *Top row*: What looks like a building on fire is actually the effect of raindrops on the lens of the camera. The scraggly lines in the negative *at the right* were traced by Christmas lights which registered on the film while it was wound —the camera's shutter, stiff from cold, had failed to close immediately and completely after the exposure. The negatives *at the bottom* show emulsion defects which occurred during manufacture.

Exposure too short

Development too short

Normal negative

Exposure too long

Development too long

The ability to "read" a negative correctly in regard to contrast and density is an indispensable prerequisite for successful darkroom work. Specifically, a photographer must be able to distinguish between the effects of underexposure and underdevelopment, overexposure and overdevelopment. These are illustrated above and their characteristics summed up below.

Character of the negative			Cause of the defect	
Too thin	and too contrasty	=	Exposure	too short
	and too contrastless	=	Development	
Too dense	and too contrastless	=	Exposure	too long
	and too contrasty	=	Development	

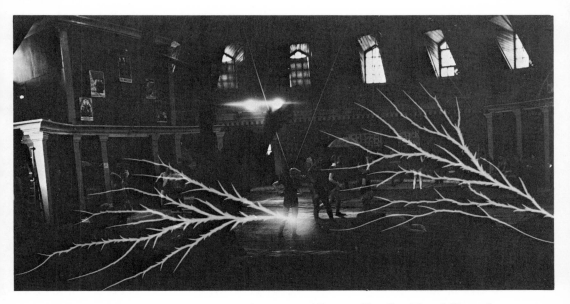

Static electricity generated by winding film too rapidly or pulling the tabs of filmpack too fast, produced these marks which can totally ruin a negative (see also p. 102). This danger is particularly imminent on dry, cold winter days and nights. Static marks always appear dark in the negative and light in the print. Instructions for avoiding them are on p. 98.

Wrinkling of the emulsion (reticulation) is caused either by an excessively warm processing solution, wash water that was too warm, or excessive temperature differences between successive baths. (See illustrations on p. 106.)

Fingermarks are caused by handling still damp films with dry hands, or dry films with moist hands, usually when threading 35mm or roll film into the grooves of the developing reel or when loading sheet-film holders. (See illustrations on p. 100.)

Scratches, digs, or abrasion marks in the emulsion or on the back side of the film may be due to one of the following causes: grit or sand in the camera; cinching a roll film (winding it too tight) by holding the roll in one hand and pulling the free end of the film (or the backing paper) with the other; fingernails that are too long; grit imbedded in the sponges used to clean the film before hanging it up to dry; or pulling roll film or 35mm film through the film carrier of the enlarger under pressure. (See illustrations on p. 103.)

Marbled, mottled, or honeycomb-like texture, particularly noticeable in areas of uniform, medium density, is caused by exhausted developer, insufficient agitation during development, or development that was prematurely terminated in a futile attempt to prevent an overexposed film from turning too black.

109

Shorter-than-normal
(Underdevelopment)

Development
Normal

Longer-than-normal
(Overdevelopment)

Shorter-than-normal
(Underexposure)

Exposure
Correct

Longer-than-normal
(Overexposure)

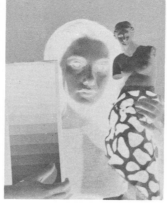

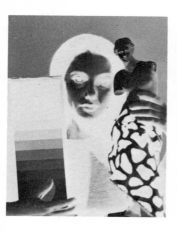
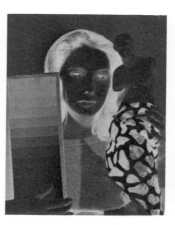

The nine negatives

From left to right and top to bottom, these are the nine possible combinations of exposure and development and their results in terms of density and contrast of the negative. In addition to the examples shown here, any number of intermediary as well as more extreme stages are, of course, possible.

1. *Underexposed and underdeveloped.* Overall density and contrast extremely low, shadow detail absent, highlights too weak. Remedy: None; this kind of negative is a total loss.

2. *Underexposed but normally developed.* Overall density too low, contrast slightly higher than normal, shadow detail inadequate, highlights printable. Remedy: If shadow detail is present, print on paper of hard gradation, burn in highlights. Intensification normally not advisable.

3. *Underexposed and overdeveloped.* Overall density approximately normal, contrast relatively high, thin areas fogged, highlights barely printable. Remedy: Print on paper of soft gradation.

4. *Correctly exposed but underdeveloped.* Overall density low, contrast low, shadow detail present but very thin, highlights too weak. Remedy: Print on paper of hard gradation.

5. *Correctly exposed and correctly developed.* Overall density, contrast, and shadow detail normal, highlights strong but still transparent. Negative should print well on No. 2 or 3 paper.

6. *Correctly exposed but overdeveloped.* Overall density too high, contrast high, shadow detail very strong, highlights too dense and partly blocked; pronounced graininess. Remedy: Print on paper of relatively soft gradation; if necessary, reduce negative in a potassium persulfate reducer (Kodak R-15, see p. 114).

7. *Overexposed and underdeveloped.* Overall density more or less normal, contrast low, shadow detail strong, highlights normal. Remedy: Print on paper of hard gradation.

8. *Overexposed but normally developed.* Overall density too high, contrast low, shadow detail very strong, highlights much too dense; possibility of halation (highlights spilling over into the shadows); pronounced graininess. Remedy: Reduce in a ferricyanide reducer (Kodak R-4a, see p. 114).

9. *Overexposed and overdeveloped.* Overall density extremely high, the entire negative appears more or less black; contrast approximately normal; highlights solid black; extreme halation and graininess. Remedy: Try to print on paper of normal gradation; if exposure times too long, reduce in a proportional reducer (Kodak R-4b or R-5, see p. 113).

HOW TO CORRECT MISTAKES

As already mentioned, most mistakes in photography are final, and although textbooks frequently give advice on how to correct disasters, most of these remedies are, in my experience, not worth the effort. Therefore, in the following section, I'll discuss only those salvage techniques that I myself have found practical.

Negatives that are too dense can be reduced, or made more transparent. However, before anyone reduces a negative, he should consider the following: Reduction is a process which, with bad luck, might end with the destruction of the image. Question number one: Is it really necessary to reduce the respective negative? Or will simply increasing the exposure time during enlarging suffice to make it yield a decent print? If the answer is no, the next question should be: Is the excessive negative density due to overexposure, overdevelopment, or fogging of the film (pp. 69, 110)? The reason for this inquiry is the fact that a photographer has the choice of three different types of negative reducers:

Proportional reducers decrease density in an amount that is proportional to the original density and give particularly good results in cases of overdevelopment.

Super-proportional reducers attack the highlights to a proportionally higher degree than the shadows, lower the contrast, and are most suitable for reducing overdeveloped negatives of constrasty subjects.

Subtractive or cutting reducers more or less preserve negative contrast by removing nearly equal density quantities from dense, medium, and thin negative areas and are therefore particularly useful for reducing overexposed or fogged negatives.

General considerations. Negatives intended for reduction should be thoroughly fixed, washed, and free of scum deposit or stain. Kodak recommends hardening before treatment in the following bath:

Kodak Special Hardener SH-1

Water	500cc
Kodak formaldehyde, about 37% solution by weight	10cc
Kodak sodium carbonate, monohydrated	6 g
Water to make	1 liter

Treat negatives for three minutes, then rinse and immerse for five minutes in a fresh acid fixing bath. Wash thoroughly before giving any further treatment.

I prefer to reduce negatives immediately after they have been fixed in an acid hardening fixing bath, dispensing with the special hardener. What is important, however, is that the negatives be treated one sheet or one roll (or section of a roll) at a time in a white or, still better, clear-glass tray illuminated from below, so that the progress of reduction can be followed visually in transmitted light; that the negatives be agitated constantly; that reduction be carried out in steps and be stopped too early rather than too late; and that reduced negatives be thoroughly washed and carefully wiped before drying. Except for stock solutions, the baths listed in the following should be prepared immediately before use and discarded afterwards.

Kodak Proportional Reducer R-4b to correct for overdevelopment:

Solution A

Kodak potassium ferricyanide	7.5 g
Water to make	1 liter

Solution B

Kodak sodium thiosulfate (hypo)	200 g
Water to make	1 liter

Treat the negative in Solution A with constant agitation until the desired degree of reduction is reached, but be extremely careful not to carry the process too far. Immerse in Solution B for five minutes, then wash and dry as usual. I always reduce negatives in steps, going back and forth between Solutions A and B in order not to risk destroying the image through over-reduction.

Kodak Proportional Reducer R-5 to correct for overdevelopment:

Stock Solution A

Water	1 liter
Potassium permanganate	0.3 g
Diluted sulfuric acid	16cc

(To prepare, slowly add one part concentrated sulfuric acid to nine parts water while stirring. *Never* add the water to the acid because this may cause boiling, spattering acid on face and hands.)

Stock Solution B

Water	3 liter
Kodak potassium persulfate	90 g

For use, add one part Stock Solution A to three parts Stock Solution B. The reduced negative should be cleared in a 1% solution of sodium bisulfite. Wash negative thoroughly, then wipe and dry as usual.

113

Kodak Super-proportional Reducer R-15 to correct for overdevelopment and simultaneously reduce contrast:

<div align="center">Stock Solution A</div>

Water	250cc
Diluted sulfuric acid	15cc

(To prepare, slowly add one part concentrated sulfuric acid to nine parts water while stirring. *Never* add the water to the acid because this may cause boiling, spattering acid on face and hands.)

Water to make	500cc

<div align="center">Stock Solution B</div>

Water	1 liter
Potassium persulfate	30 g

For use, add one part Stock Solution A to two parts Stock Solution B. Use only glass or stainless steel trays. Stop the reducing process when the required degree of reduction is *almost* (but not quite) reached by immersing the negative for a few minutes in an acid fixing bath. Wash thoroughly, wipe and dry as usual. The shelf life of Stock Solution B is two months if stored in a cool and dark place.

Kodak Subtractive Reducer R-4a to correct for overexposure and to remove fog:

<div align="center">Stock Solution A</div>

Kodak potassium ferricyanide	35 g
Water to make	500cc

<div align="center">Stock Solution B</div>

Kodak sodium thiosulfate (hypo)	480 g
Water to make	2 liter

For use, add 15cc of Stock Solution A to 60cc of Stock Solution B, then fill up with water to make 500cc. The mixture must be used immediately, since it decomposes in a very short time, turning from yellow to green. If less rapid action is desired, combine 8cc of Stock Solution A with 60cc of Stock Solution B, and fill up with water to make 500cc.

Negatives that are too thin can be intensified (made more dense). However, there are serious drawbacks to this process, and before attempting

intensification of an excessively thin negative, a photographer should consider the following:

Even the best intensifier can only strengthen an image that is already there; if parts of the negative are completely clear (or show only uniform fog density), there is no use in attempting intensification.

Intensification always involves a certain danger of ruining the image. Before attempting it, a photographer should therefore try to make the best possible print on hard or extra hard paper. He may then find that intensification is really not necessary.

The most effective intensifiers not only produce results that are relatively impermanent, but also involve the use of deadly poisons such as mercury chloride and sodium cyanide, of which the latter, in combination with an acid, reacts to form the fatal gas hydrogen cyanide. Therefore, I consider these intensifiers too dangerous for use except by experts.

Kodak Chromium Intensifier In-4

Stock Solution

Water to make	1 liter
Kodak potassium dichromate	90 g
Hydrochloric acid (concentrated)	64cc

For use, add one part Stock Solution to ten parts water. Harden the negative first in Kodak Special Hardener SH-1 (p. 112). Bleach thoroughly at 65° to 70°F., then wash for five minutes, and redevelop the negative for about ten minutes by artificial light or daylight (but not in the sun) in Kodak Developer D-72 diluted 1:3 at 68°F. Rinse, fix for five minutes, then wash and dry as usual. Still greater intensification can be achieved if the process is repeated.

Minor scratches in negatives can be minimized or eliminated in the print by rubbing a thin coat of petroleum jelly (Vaseline) on the negative or treating it with Scratch-Patch, a commercial preparation available in most photo stores. Some photographers prefer to prepare their own anti-scratch solution in accordance with the following formula:

Water	500cc
Chloral hydrate	50 g
Gelatin	13 g

Dissolve the chloral hydrate in the water, then cut the gelatin into small pieces and add them to the solution.

Let the gelatin swell, then warm the mixture in a water bath until the last of the gelatin is dissolved, being careful not to let it exceed a temperature of 140°F.

Dirty negatives can be cleaned with the following cleaner, which removes grease, fresh (but not old) fingermarks, and coatings of dirt and dust:

Acetic acid	1 part
Petroleum jelly (Vaseline)	5 parts
Carbon tetrachloride	100 parts

Shake the solution well before use, then apply it lightly and without undue pressure with a soft cloth, gently rubbing it onto the negative. Let the cleaner act for about ten minutes, then carefully rub it off until the negative appears perfectly clean.

Negative defects that cannot be corrected include the following: mottling caused by insufficient agitation during development; streaks of uneven density caused by incorrect agitation during development; clear spots due to air bubbles adhering to the developing films; reticulation of the emulsion; water marks left by drops that dried on the film; old fingermarks that have eaten into the film; deep scratches and digs in the emulsion; the effects of flare and halation; the effects of light leaks and stray light that fogged the film unevenly; static marks; true and pseudo-solarization; and particles of dust and lint imbedded in the emulsion.

In such cases, the photographer has the choice of three possibilities:

1. Correcting the defect by retouching the print.

2. Enlarging the undamaged section of the negative while cropping off the useless part.

3. Discarding the negative and writing it off as experience.

VI. Basic photo-chemistry

At first glance, a special chapter on photochemistry may seem superfluous in an unpretentious guide like this, especially in view of the fact that all the photochemistry a photographer normally needs can be summed up in one sentence: Open a can of developer (or fixer and so on), pour the contents into a measured amount of water, and stir until dissolved. . . .

However, although this may be true as far as the majority of readers is concerned, there will always be those few who wish to prepare their own solutions for one or all of the following reasons:

Economy. Even though it is more *practical* to buy developers, fixers, and so forth in prepared form, it is considerably *cheaper* to mix your own solutions from chemicals bought in bulk. This applies particularly to fixers and fine-grain developers.

Availability. Although the number of published formulas for developers, fixers, correction baths, toners, and so on is enormous, only a relatively small selection of these processing aids are commercially available in prepared form. Furthermore, some photographic solutions are so unstable that they have to be prepared immediately before use. Therefore, unless a photographer is willing to be satisfied with what is commercially available, he must prepare these special solutions himself.

Versatility. Merely by mixing them in different combinations or varying their relative proportions, a comparatively small number of basic photographic chemicals can be made to yield a large number of different developers, fixers, and so on, each with its own characteristics. Furthermore, because their components are known to the photographer, user-mixed developers can easily be modified in regard to their characteristics—tailored to fit the specific needs of the photographer—whereas tampering with prepared solutions invites disaster.

THE EQUIPMENT FOR COMPOUNDING SOLUTIONS

Only a few items are needed in addition to those already listed under General Equipment (pp. 47–48). Here is a check-list of *everything* you need.

Laboratory balance and a set of weights from 1/10 to 100 g. Once you have decided to go in for mixing your own solutions, buy a good one. It will last you a lifetime.

Three graduates of 1000-, 500-, and 10cc capacity. In my opinion, stainless steel is best for the large one, plastic for the smaller ones.

Two funnels, one large, one small.

Mixing vessels in different sizes. Stainless steel is unsurpassed; Pyrex glass is chemically excellent but subject to breakage; plastic is cheap and practical.

A *set of spoons* in different sizes for taking chemicals out of their containers. Again, stainless steel and glass are best; plastic discolors, metal is not chemically inert, wood absorbs chemicals.

Several stirring rods with flat ends, for stirring solutions and crushing residual crystals.

Mason jars or wide-necked glass jars with plastic screw tops and gaskets in assorted sizes for storing dry chemicals. Although some chemicals are sensitive to light (p. 122), clear glass containers are perfectly suitable as long as they are stored in the dark.

Polyethylene bottles in assorted sizes with *plastic* screw tops or *rubber* stoppers for storing stock solutions. Metal screw tops rust very soon, contaminate the solution, and are totally unsuitable. Cork absorbs chemicals and should be avoided. Glass stoppers in bottles are subject to sticking.

Darkroom thermometer for checking the temperature of the water used to dissolve chemicals that either are sensitive to heat (p. 122) or require heat for complete dissolution.

Filter paper or absorbent cotton for filtering solutions.

White, inch-wide adhesive tape from which to cut labels for bottles and jars.

ADVICE ON HANDLING CHEMICALS

Although most photographic chemicals are relatively harmless (for some exceptions, see list of POISONOUS Chemicals, p. 122), observation of the following rules will avoid potential trouble in the form of skin irritation, stains and spots on negatives, prints, or clothing caused by chemical contamination, mixups resulting in wasted film and paper, and so forth.

Read labels carefully. The information they contain was put there for your information and protection. Pay particular attention to warnings. A chemical may be poisonous, cause skin irritation, or be sensitive to heat or light.

Handle chemicals carefully. In particular, avoid contact with the skin. Do not dip your hands into processing solutions, do not splash, do not fill processing trays too high. In case of accidental contact, wash off chemicals immediately under running water. If chemicals get into your eyes, wash the eyes immediately with running water (the best way: by means of the short rubber hose attached to a faucet, as mentioned on p. 36). If the chemical is an acid, wash with a very dilute solution of bicarbonate of soda; if an alkali, with a very dilute boric acid solution. If necessary, seek medical attention. Some photographic chemicals, particularly certain developing agents, may cause skin allergies; if this is the case, switch to a different developer.

Store chemicals and processing solutions in a safe place, particularly out of reach of children. And although it is good practice to keep film in factory-sealed packages in the refrigerator or freezer (where they will stay fresh almost indefinitely), photographic chemicals and solutions should never be stored in these places where they would be accessible to anyone, may be mistaken for edible material, or contaminate food.

Make sure that chemicals or solutions cannot get into your mouth. Do not eat in your darkroom or, for that matter, in any room where chemicals are mixed or used. Do not start a siphoning action with your mouth; instead, fill the tube with the solution by immersing it in the liquid, then lowering its free end until the liquid starts to flow.

Maintain adequate ventilation in your darkroom by means of a lighttight darkroom fan. Although this is particularly important in regard to color

processing, some chemicals used in black-and-white processing also give off irritating vapors, specifically the *acetic acid* of a stop bath, the *sulfur dioxide* of a fixer, and the *formaldehyde* of a hardener.

Wear a waterproof apron. Kodak makes a very good black vinyl one. Protect your hands with one of the commercially available, protective hand creams used in industry. I have found *Kerodex 71* excellent; you can get it in most drugstores. Photographers subject to skin allergies may have to resort to wearing protective rubber gloves.

Keep your darkroom clean. Specifically, wipe up accidentally spilled chemicals or solutions as soon as practicable because chemicals in powder form as well as residue from dried solutions may become airborne, contaminate the entire darkroom, and may even be inhaled. For the same reason, do not mix solutions involving chemicals in powder form in the darkroom.

When pouring used solutions down the drain, always follow up with plenty of water. When I dump a fixing bath, I always pour the hypo neutralizer bath after it to neutralize the fixer. Users of large quantities of photographic chemicals can find specific information regarding waste disposal in the Kodak publication No. J-28, *Disposal of Photographic-Processing Wastes.*

ADVICE ON BUYING CHEMICALS

The most important considerations are *suitability, purity, uniformity,* and *freshness.* Perhaps nowhere in photography can false economy have a more devastating effect than when it comes to buying photographic chemicals where saving a few pennies can ruin an entire take. In this respect, fine-grain developers, intensifiers, and toners are particularly sensitive, because even slight impurities can imbalance these solutions to a degree where they become useless. Therefore, the reader is advised to give preference to chemicals prepared specifically for photographic purposes, and to buy only through a reputable photo supply house or drugstore. As far as purity is concerned, the following technical terms are in general use:

Technical = of relatively low grade and, except for stop baths and fixers, unsuitable to photographic work.

120

Purified = of medium quality, good enough only for stop baths and fixers.

U.S.P. = of high quality, meeting the specifications of the United States Pharmacopoeia and suitable for any kind of photographic work. With minor differences, this corresponds to the British Pharmacopoeia grading **B.P.**

A.R. = "Analytical Reagent," of highest purity, intended primarily for analytical purposes and unnecessarily pure and expensive for most types of photographic work.

Photographic Grade = meeting the requirements of the United States of America Standards Institute (formerly American Standard Association or ASA) or the British Standards Institute.

A common source of confusion is the similarity in the endings of the names of certain chemicals. When compounding a published formula or buying chemicals, the reader should therefore pay particular attention to the following:

The ending "ate" signifies a chemical containing a relatively high amount of oxygen, for example, sodium sulfate.

The ending "ite" signifies a chemical containing a relatively small amount of oxygen, for example, sodium sulfite.

The ending "ide" signifies a binary chemical compound, for example, sodium sulfide.

ADVICE ON STORING CHEMICALS

The best way of storing chemicals is in glass containers, the worst in paper bags. Cardboard containers are hygroscopic, that is, retain moisture absorbed from the air, which promotes clumping and decomposition of their contents. Mason jars are excellent for storing dry chemicals; if such chemicals are sensitive to light (p. 122), the jars must be stored in darkness.

Jars and bottles should be equipped with plastic screw caps or rubber stoppers. Metal screw tops are totally inadequate, because they will soon rust and contaminate the contents of the bottle or jar. Cork stoppers absorb chemicals and should be avoided. Glass stoppers have an annoying tendency to stick; to loosen, heat the neck of the jar from all sides with a match, then lightly tap the sides of the neck with a piece of wood, and twist the stopper counterclockwise. When replacing the stopper, apply a thin coat of petroleum jelly to avoid further trouble.

Since most photographic chemicals are sensitive to moisture, air, and heat, and a few to light and cold, the storage place must be dry, cool but

not cold, and dark. Chemicals that give off fumes (p. 122) must be stored away from film and sensitized paper. All containers should be clearly labelled and poisonous chemicals identified in addition by a skull-and-cross-bones sticker.

Poisonous: The following chemicals are poisonous and should never be touched or permitted to come in contact with the skin: caustic soda (developer alkali), potassium bichromate (intensifier), sulfuric acid (cleanser for developer trays which gives off poisonous fumes that are extremely harmful to the lungs), uranium nitrate (intensifier), potassium ferricyanide (reducing agent), pyrogallol (developing agent).

Sensitive to moisture to a particularly high degree are the following chemicals, which avidly absorb moisture from the air and should be kept on the highest shelf in the room where the air tends to be drier than near the floor: amidol, ammonium persulfate, caustic soda, pyrocatechin, glycin, hydroquinone, metol, potassium carbonate, and pyrogallol.

Sensitive to heat to a particularly high degree are the following chemicals, which must be dissolved only in cold water or added to cold (68°F.) solutions: acetic acid, ferric oxalate, potassium metabisulfite, and sodium bisulfate.

Sensitive to light are the following chemicals, which must be stored in darkness: ferric oxalate, gold chloride, potassium ferricyanide, potassium iodine, potassium permanganate, and silver nitrate.

Sensitive to air, from which they absorb oxygen, are all developing agents (p. 132) and developers in solution. To avoid premature spoilage through oxidation, developer bottles must therefore be filled all the way to the top. Plastic bottles should be filled as high as practicable and then squeezed, to force the solution to the very top before the screw cap is put on tightly. If glass bottles are used, glass pellets can be dropped into the bottle until the level of the solution reaches the top, leaving only a small space so that volume fluctuations due to a change in temperature will not loosen the stopper or crack the bottle. Large amounts of stock solution should be divided among a number of small bottles rather than be kept in a single large one. In this way, whenever the photographer draws developer from his stock, only a relatively small amount has to be exposed to air while the rest remains undisturbed.

Fumes that fog photographic emulsions are given off by the following chemicals, which must be stored away from film and sensitized paper: ammonia water, ammonium sulfide, and formaldehyde.

ADVICE ON THE PREPARATION OF SOLUTIONS

Prepared developers, fixers, and so on should, of course, be dissolved, diluted, or mixed in strict accordance with the manufacturer's instructions, with special attention given to sequence and temperature.

Published formulas usually list their ingredients in the order in which they must be dissolved.

Vessels of stainless steel, glass, or polyethylene are most suitable for dissolving and mixing chemicals. Enamelled steel containers chip and rust and may release alkali, which would spoil some fine-grain developers. Hard rubber absorbs certain chemicals, which subsequently might contaminate other solutions. Glazed stoneware is subject to cracks in the glaze, through which chemicals can penetrate, be absorbed by the clay, and contaminate subsequently prepared solutions. Vessels made of aluminum, copper, zinc, tin or their alloys, or galvanized iron are unsuitable for photographic purposes and should not be used.

When weighing chemicals, in order to avoid the danger of contamination, place a piece of paper on each of the two pans (to preserve the equilibrium), then pour the chemical onto the paper (instead of directly on the pan). It is permissible to use the same piece of paper for weighing all the ingredients that go into the same formula. The scale should, of course, be zeroed in before each use.

Small quantities of chemicals must be measured particularly accurately. When measuring a liquid, use a *small, cylindrical* (not tapering) glass graduate, raise it until the surface of the liquid is level with your eye, then take the reading *at the bottom* of the curve formed by surface tension at the top of the liquid.

When taking a thermometer reading, make sure that your eye is level with the top of the indicator column; otherwise, the refraction effect of the cylindrical magnifier built into the thermometer rod may falsify the reading by as much as two degrees. Rod-type thermometers are generally more accurate than dial thermometers.

Dry, and especially desiccated, chemicals must always be poured *slowly* and *under constant stirring* into the water. Pouring water over desiccated chemicals causes them to cake into a stony mass, which takes a very long time to dissolve.

Acid must always be poured slowly into water. Reversing the process— pouring water into acid—can be extremely dangerous, causing the acid to boil and spatter on the hands, face, and perhaps into the eyes of the operator.

Vigorous but not excessive stirring during the mixing operation increases the rate of solution and helps to prevent undesirable effects. However, care must be taken not to splash, or whip air into the solution, particularly while preparing a developer since excessive agitation may introduce sufficient air into the developer to weaken it noticeably and produce staining compounds. On the other hand, insufficient agitation may cause chemicals to settle at the bottom of the vessel where they might form a stony mass that would dissolve only very slowly. If water is added to a solution, thorough stirring is required to properly mix solution and water, since the concentrate is heavier than the water and would collect at the bottom of the vessel unless stirred up.

Used developers should be filtered by pouring them through a funnel lightly stoppered with a wad of absorbent cotton before reuse in order to eliminate gelatin particles, sludge, and dirt that might otherwise settle on the films and cause spots. However, care must be taken first to warm the solution to be filtered to working temperature; at lower temperatures, some chemicals crystallize and would be filtered right out of the solution, making it useless.

Cleanliness, as stressed repeatedly, is one of the prime conditions for satisfactory darkroom work. Therefore, experienced photographers do not prepare solutions that involve chemicals in powder form in the darkroom or in places where sensitized materials are used. When opening a can of developer and pouring it into the water, for example, it is virtually impossible to prevent a small puff of powder from escaping into the air, wafting through the room, and settling down to do its dirty work, causing spots in negatives and prints and contaminating equipment. Accidentally spilled chemicals and solutions should be wiped up before crystalline substances can become airborne or solutions dry, crystallize, and contaminate the entire darkroom. This applies particularly to spilled fixer, a frequent cause of "inexplicable" spots on negatives or prints.

All the paraphernalia used in the preparation of solutions should be thoroughly washed immediately after use to prevent the formation of deposits that might contaminate prepared solutions subsequently. Although it is always advisable to use separate mixing vessels for developer, fixer, and so forth, if only one vessel is available, solutions should be mixed in the order in which they will be used in processing. For example, small quantities of developer in a fixer are relatively harmless, but traces of fixer in the developer can seriously impair its efficacy. Developer deposits on tanks, developing reels, trays, or film hangers start as harmless stains but grad-

ually build up to form scale which eventually flakes off, settles on the developing films and prints, and causes spots. This scale should be removed periodically with the aid of Kodak Tray Cleaner TC-1 or TC-3 (which must not be used on chromium-plated metal articles, because it might attack the copper undercoating). If this proves ineffective, fill the tank or tray with Kodak Stop Bath SB-1, and let it stand overnight; this should loosen the scale, which then can be removed with a wire brush. If this also fails to do the trick, try a solution of Kodak Developer System Cleaner, and allow it to stand for half an hour. To remove the spongy deposit that tends to accumulate on metal film hangers and clips (it can absorb chemicals and thereby contaminate solutions), soak the hangers or clips for an hour in a bath consisting of one part glacial acetic acid and nine parts of water; subsequently, scrub off the deposit with a wire brush, then wash thoroughly with water.

The water for solutions

As far as the darkroom worker is concerned, water has two important qualities: *degree of purity* and *temperature*. Normally, ordinary tap water that is fit to drink is also good enough for the majority of photographic purposes. For years I persuaded myself that developer stock solutions could be prepared only with boiled water. Boiling, in addition to precipitating impurities and calcium and magnesium salts, eliminates air dissolved in water, and air contains the oxygen that oxidizes the developing agent, turns the solution brown, and makes it useless. I also believed that fine-grain developers could only be made with boiled and distilled water. Distillation purifies water by removing all other constituents, leaving chemically pure H_2O. However, according to the instructions accompanying most prepared developers, these precautions are unnecessary, and when I prepared a test stock solution with ordinary tap water, lo and behold! it kept just as long as the control solution made with boiled water.

Except for sulfides, which interfere with proper developing and fixing, most photographically potentially harmful impurities found in ordinary drinking water can be either eliminated or reduced to a harmless level by installing a filter in the main water supply line of the darkroom. Such filters are available in a number of different models and can be installed by any plumber. Specifically, they accomplish the following:

A water filter eliminates iron stemming from rusty water pipes, which otherwise would increase the rate of oxidation of the developer, besides causing rust spots on negatives and prints. It also retains a high degree of organic matter—a fact of particular interest to photographers who, like myself, live in the country and draw their water supply from a well. Impurities

of an organic nature, primarily algae and bacteria, flourish in a developer and are the causative agents of the slime so often found accumulating in developing tanks and wooden darkroom sinks. They may also act on the sulfite, which is an indispensable ingredient of any developer and convert it to sodium sulfide, which fogs photographic emulsions. Furthermore, organic matter is likely to interfere with proper washing, since it tends to coagulate by combining with the alum carried over from the fixer and form a slimy deposit on negatives and prints. Photographers who are experiencing this nuisance to a particularly high degree should add 15 g of boric acid to every liter of their acid fixing bath.

Preparing a developer with abnormally hard water may result in a finely divided precipitate. This precipitate can usually be avoided by the addition of Kodak Anti-Calcium. However, experience has shown that it is photographically harmless, even if it should not settle down (when it can be eliminated by slowly decanting the developer), but remains in suspension.

The temperature of solutions

Basically, the rate of solution increases with temperature, and vice versa, but certain chemicals are sensitive to heat (p. 122) and cold. This has the following consequences:

All chemicals dissolve more rapidly and in greater quantities in warm than in cold water. However, there is a limit, and when this limit is exceeded, additional amounts of the respective chemical will no longer dissolve but will precipitate. At this point, the solution is *saturated*. Conversely, chilling a solution below its working temperature may cause precipitation of some of its components. This is the reason why photographic solutions must never be filtered at temperatures below 68° F.

Developers can usually be prepared with water as hot as 125° F. However, when you dissolve prepared developers in powder form, the manufacturer's instructions may specify a lower limit. *Working temperature* of all but tropical developers is, of course, 68° to 75° F. *Storage temperature* has a great influence upon the shelf life of a developer stock solution. Kodak, for example, states that a developer that normally keeps for two or three months at 65° to 70° F. may be spoiled within a few days if kept at 90° to 95° F. On the other hand, below 55° F., certain developer components may crystallize out of solution and subsequently redissolve only reluctantly or not at all, even when heated. Repeated changes in temperature can also have a detrimental effect upon the keeping properties of many photographic solutions.

126

Hypo crystals can be dissolved in water as hot as it comes out of the faucet. Pouring hypo crystals into water of 140° F. almost instantly lowers its temperature to somewhere around 50° F. Before it is ready for use, the temperature of such a bath must, of course, be raised to 68° to 75° F. in order to avoid reticulation of the negatives (p. 106).

Packaged fixing baths should normally be dissolved only in water not exceeding 80° F. Consult the manufacturer's instructions.

The concentration of solutions

The concentration or strength of photographic solutions is indicated in one of three ways:

Fill up with water to make. A common way of writing the formula for, say, a developer is to list the various ingredients in the order in which they must be dissolved, followed by a last line reading "water to make one liter." To prepare such a formula, the chemicals are first dissolved one after another in an amount of water that is *smaller* than the final volume or, in our example, perhaps 700cc. Then, when all the chemicals have been added, the mixture should be poured in a graduate holding at least one liter, and water be added until the one-liter mark is reached. The difference in water volume between the amount used to dissolve the chemicals and the final amount of one liter depends on the volume of the required ingredients. If the difference is too small, the one-liter mark would be reached before the formula is complete and the concentration of the final solution would be too low. If the difference in water volume is too large, the first solution may reach the state of saturation before all the chemicals can be dissolved.

Percentage solution. To make, for example, an 8% solution, dissolve 8 g of the specified chemical in *less* than 100cc of water, say 70cc; then add water until the 100cc mark is reached. The difference in volume between the water used to dissolve the chemical and the final volume of 100cc, for reasons explained above, must be neither too large nor too small. And most important: Both the chemical and the water must be *measured in the same unit of weight.* In the decimal system, 1cc of water weighs 1 g; therefore, cubic centimeters (cc), grams (g) and milliliters (ml) are completely interchangeable, and measuring vessels calibrated in milliliters can be used to measure quantities given in cubic centimeters. Unless this rule is observed, the percentage of the solution will be incorrect. Graphically, a percentage solution can be expressed as follows:

Percentage solution Parts solution

Parts solution. This form of expressing the strength of a solution is primarily used for converting a stock solution into a working solution. For example, to convert a specific stock solution to a working solution, you may have to mix, say, one part stock solution with three parts water. This, of course, is very simple, *provided identical units of measurement are used for both stock solution and water.* Such units can be anything from cubic centimeters to cubic meters, provided all the parts are reckoned in the same unit of weight or volume. In our example, it would make no difference whether we take, say 100cc of stock solution and add to it 300cc of water, or take 12 fl. oz. of stock solution and mix it with 36 fl. oz. of water; the concentration of the working solution would in both cases be the same. If the parts-formula includes both solids and liquids, equivalent units of measurement must, of course, be used. In that case, grams for solids go with cubic centimeters for liquids, and ounces for solids go with fluid ounces for liquids.

Conversion of a parts-solution into a percentage-solution is easy if you proceed as follows: The solution given as an example above consisted of one part stock solution and three parts water, or all together four parts. To convert this ratio to percentages, divide 100 by 4, and get as the result 25. In other words, a parts-solution of 1:3 is equivalent to a 25% solution.

To convert a high-percentage stock solution into a lower-percentage working solution, use the criss-cross method and proceed as follows:

Write the percentage strength of the solution of higher concentration at *A*.

The criss-cross method

Write the percentage strength of the solution of lower concentration at *B* (if this solution is plain water, the percentage strength is, of course, 0). Write the desired percentage strength at *X*. Now, subtract *X* from *A*, and write the result at *D*; then subtract *B* from *X*, and write the result at *C*. Finally, take *C* parts of *A*, add them to *D* parts of *B*, and you will have an *X* per cent solution.

For example: To convert a 99% stock solution of glacial acetic acid into a 28% working solution, take 28cc of the 99% stock solution and add to it 71cc of water. This will give you your 28% working solution.

The keeping properties of solutions

Whereas some photographic solutions will keep virtually indefinitely, others decompose sooner or later even when they are not used. Basically, concentrated stock solutions keep longer than diluted working solutions; solutions keep longer in bottles filled to the top than in only partly filled bottles or in open tanks or trays; and unused solutions keep longer than used ones.

Apart from contamination with other chemicals (for example, developer carried over into the fixer) and, of course, exhaustion through use, the greatest obstacles to long solution life are exposure to air and heat. Consequently, stock solutions should be kept in bottles that are filled to the top, tightly stoppered, and kept in a relatively cool (but not cold) place. Used film developers that are worth saving for reuse should be filtered and poured back into their bottles (methods for keeping out air were listed on p. 53). If left in deep tanks, they should be protected from exposure to air and dust by a floating cover of polyethylene or Kodapak Sheet. To make such a cover, bend up the four edges of the plastic sheet to form a shallow tray about two inches deep and slightly smaller than the inside of the tank; then fasten a handle to its center with Epoxy glue or Kodak Film Cement. Used paper developers cannot be reused and are dumped.

The capacity of solutions

The capacities of photographic solutions vary just like their keeping qualities. And just as important as it is to use only solutions that have not deteriorated through age, so it is important to work only with baths that are not exhausted through use. With increasing exhaustion, film developers act more and more sluggishly and yield negatives that are progressively thinner and softer, and paper developers produce prints in sickly brownish tones. Exhausted fixers are even more insidious because, unlike developers, which turn brown, they do not display any visible signs of exhaustion; although they may still clear films and make prints insensitive to light, such negatives and prints are no longer permanent and will soon discolor and fade.

To give the reader an idea of the keeping properties and capacities of photographic solutions, I list in the following table data for some of the more popular Kodak developers, stop baths, and fixers. These figures are based upon information published by Kodak. Keeping properties apply to unused solutions stored at 65° to 70° F. and would be lower at higher temperatures. Capacities are based upon normal use without replenishment. Somewhat longer life and increased capacity can be assumed if a certain change in quality is acceptable. A more complete table listing almost 50 different Kodak products can be found in the Kodak Professional Data Book J-1, *Processing Chemicals and Formulas for Black-and-White Photography.*

Note that, in the table at right, the capacity of each solution is given in terms of 8″ x 10″ sheets per liter. In this respect, one 8″ x 10″ sheet is equivalent to the following: one 36-exposure roll of 35mm film; one roll of 120 roll film; half a roll of 220 roll film; one roll of 620 roll film; two rolls of 127 roll film; three rolls of 828 or 126 (12-exposure) roll film; four sheets of 4″ x 5″ film; six sheets of 3¼″ x 4¼″ film; or 11 sheets of 2¼″ x 3¼″ film.

Note furthermore that the capacity of any developer decreases if only single films or a few films are developed at one time and the solution stands unused during the intervals. On the other hand, if a developer is used only once to develop a maximum number of films at one time (called "one-shot development," p. 53), a somewhat greater quantity than that indicated in the table at the right can be processed with good results.

	Keeping properties without use				Capacity	
	Stock solution in bottle		Working solution		8" x 10" sheets per liter	
	Full	½-full	In tray	In tank	In tray	In tank
Developers						
D-72	6 mo.	2 mo.	24 hr. (1:1)	2 wk. (1:1)	8 (1:1)	10 (1:1)
D-76	6 mo.	2 mo.	24 hr.	1 mo.	4	4*
D-76 (1:1) Do not store. Discard after use.					2	2
Microdol-X	6 mo.	2 mo.	24 hr.	1 mo.	4	4*
D-72	6 mo.	2 mo.	12 hr.	—	25 (1:2)	—
Dektol	6 mo.	2 mo.	12 hr.	—	30 (1:2)	—
Stop baths						
Indicator stop bath	Indefinite in original package		3 days	1 mo.	Discard when color changes.	
Stop bath SB-1	Indefinitely		3 days	1 mo.	20	20
Fixing Baths						
Kodak Fixer (if stop bath is used)	2 mo.	2 mo.	1 wk.	1 mo.	25	25
Rapid fixer (if stop bath is used)	2 mo.	2 mo.	1 wk.	1 mo.	30 negatives (1:3) or 25 prints (1:7)	
Kodak Hypo Clearing Agent	3 mo.	3 mo.	24 hr.	—	12–15 negatives without pre-rinse or 40–50 negatives with pre-rinse; alternatively, 20 prints without or 50 prints with pre-rinse	

*Capacity applies only if the life of the developer is extended by proper replenishment and developing times increased by about 15 per cent after each sheet 8" x 10" per liter.

THE CHEMISTRY OF A DEVELOPER

Development is a process that involves three basic operations: softening and swelling of the gelatin; disassociation of silver and bromide or chloride; and transformation of the exposed silver halide crystals into metallic silver, called the "grain" of the film (p. 65). To make this sequence possible, any developer must contain among its ingredients the following five components:

The solvent—water—the purpose of which is to soften the dry emulsion and make it permeable to the chemicals that will transform the latent image into a visible one.

The developing (reducing) agent, whose purpose is to reduce the silver from its compound to form the image. During this process, however, only the exposed halides must be affected; if the unexposed halides were attacked, too, the film or paper would turn uniformly gray or black. Only a few substances are known to have the necessary selective qualities, the most important ones of which are metol and hydroquinone. The first is a soft and rapid developing agent, and the second a contrasty and slow working one. By combining the two in different ratios and combinations, almost any kind of developer can be produced. Other less commonly used developing agents are amidol, glycin, orthophenylenediamine, para-aminophenol, para-phenylenediamine, pyrocatechine, and pyrogallol.

The activator (accelerator), whose purpose is to stimulate the developing agent, which works properly only in an alkaline environment, to greater activity. Consequently, the more alkaline the solution, the more energetic the developer. As a matter of fact, an overly alkaline developer will reduce not only the exposed silver salts, but also the unexposed ones, producing overall fog in the negative. Alkalis most often used for photographic purposes are sodium carbonate, borax, potassium hydroxide, and sodium hydroxide (caustic soda); of these, the first produces the least and the last the most energetic action.

The preservative, whose purpose is to protect the developing agent from the effects of aerial oxidation. Unfortunately, all reducing agents have an inherent affinity for oxygen, tending to combine with it and to rust themselves away until they become photographically ineffective, besides discoloring films and papers with brownish oxidation stains. The preservative, by combining with the oxidation byproducts of the reducing agent, prevents

this. The most commonly used preservatives are sodium sulfite and potassium metabisulfite.

The restrainer, whose purpose is to prevent an overly active (highly alkaline) developer from also attacking the unexposed silver halides and thereby causing a more or less noticeable degree of overall fog in the negative or print. The substance most widely used as a restrainer is potassium bromide.

The preparation of a developer

Published developer formulas usually list their components in the order in which they must be dissolved. Deviation from this order can (and probably will) lead to undesirable reactions and solutions that do not perform as anticipated, provided they work at all.

Unless specified otherwise, developers should be prepared with ordinary tap water of a temperature not exceeding 125° F.

Before adding a new chemical to a solution, make sure that the one previously added is *completely* dissolved. Failure to do so may result in oxidation or precipitation of chemicals and discoloration of the solution.

Normally, the preservative (sulfite) must be dissolved first, followed by the developing agent, in order to protect the latter from premature oxidation. There is, however, one exception: In the case of developer formulas containing Kodak Elon, the Elon must be dissolved first, since it is difficult to dissolve in a sulfite solution in the absence of an alkali. But as soon as the Elon is completely dissolved, the sulfite must be added promptly in order to avoid oxidation of the Elon. Follow immediately with whatever other developing agents may be required by the formula, and end with the addition of the alkali.

The alkali is always added after the preservative and the developing agent have been completely dissolved. Since alkali increases the natural affinity of the developing agent for oxygen, it would accelerate the rate of oxidation unless restrained by the preservative.

THE CHEMISTRY OF A FIXER

Development completed, the undeveloped silver salts must be eliminated from the film by fixation—not only to clear the negative and make it printable, but also to make it permanent, because, unless they were removed, the unexposed halides would eventually darken and obliterate the image. The substance used for this purpose is sodium thiosulfate, commonly known as hypo. Unfortunately, a fixing bath consisting solely of hypo and water would not remain effective very long because of contamination by chemicals carried over from the developer. To avoid premature decomposition, most fixers therefore contain among their ingredients the following components:

The solvent for undeveloped silver halides—sodium thiosulfate or hypo.

The preservative—sodium sulfite, whose purpose is to prevent the hypo from being decomposed by the acid. This would make the fixer useless. A decomposed bath can be recognized by its milky appearance. The preservative also serves to maintain the high degree of acidity necessary to neutralize the alkali carried over into the fixer by developer remaining in films and sensitized papers. And it combines with the oxygen in the fixer before it can react with the contaminating developer, thereby forestalling the developer's oxidation and preventing it from staining the fixing negatives or prints.

The acid—acetic acid, whose purposes are to neutralize the alkaline developer carried over into the fixer by the negatives or prints and to provide the most effective environment for the hardener.

The hardening agent—potassium alum or chrome alum, whose purposes are to prevent excessive softening and swelling of the gelatin of the emulsion, to harden it by its tanning action, and thereby to make it less vulnerable to mechanical injuries.

The sludge preventive—boric acid, whose purpose is twofold: to increase the hardening effect of the alum, and to retard the precipitation of aluminum sulfite sludge, which gradually would form as the fixer becomes more and more contaminated with developer.

The preparation of a fixer

To prepare a fixer, dissolve the preservative (sodium sulfite) first, then add the acid (acetic acid) to the solution. Keep in mind that the acetic acid is sensitive to heat. Do not add it to a solution that is warmer than 85° F. Acetic acid, added to a hypo solution over 85° F. warm, would turn the bath milky and spoil it.

Dissolve the hardener (potassium alum or chrome alum) in the sulfite-acid solution. If you were to add the alum directly to the sulfite without the acid, the two substances would combine to form aluminum sulfite and precipitate as white sludge.

Dissolve the hypo (sodium thiosulfate) by itself in water as hot as it comes out of the faucet.

Making sure that both solutions are not warmer than 85° F., mix the sulfite-acid-alum solution with the hypo solution.

CHEMICAL PROCESSING AIDS

A large number of prepared aids exists, and innumerable formulas and tests have been published in the photographic literature which can help to make life easier for the concerned photographer or relieve him of worry about the degree of permanence of his work. Unfortunately, some of the best tips are scattered throughout various periodicals and books, difficult to find and so condemned to oblivion. In the hope of doing the reader some good, I have collected the following chemical processing aids that I have found useful over the years.

Kodak Testing Outfit for Stop Baths and Fixing Baths comes in kit form and provides a fast and reliable method for determining whether such baths are still in working condition or exhausted. Without this aid, determining the degree of exhaustion is possible only by keeping a careful count of the number of films or papers that have been processed in the respective solutions in accordance with the table of capacities previously given (p. 131). There is no visible difference between an active and an exhausted stop or fixing bath, unless the stop bath is of the indicator type, which changes from yellow to blue-purple to indicate exhaustion.

Kodak Residual Silver Test Solution ST-1 enables a photographer to test quickly whether or not his films and papers are thoroughly fixed. To prepare the test solution, dissolve 2 g of Kodak Sodium Sulfide in 125cc of water. If stored in a stoppered bottle, this stock solution will keep for up to three months. For use, add one part stock solution to nine parts water. The diluted working solution is only moderately stable and should be freshly prepared every week. To make the test, place a drop of the working solution on the margin of a squeegeed film or print (or on an unexposed piece of the same photographic paper processed as a control together with the batch of prints). Let the drop stand for two to three minutes, then blot it with a clean paper towel or piece of white blotting paper. Any coloration in excess of a barely visible cream tint indicates the presence of silver compounds in the processed photographic material, a sign of insufficient fixing or exhaustion of the fixing bath. In that case, fixation should either be continued, if the fixer is still in working condition (see the test above), or the photographic material should be transferred to a freshly prepared fixer and fixed properly.

Kodak Hypo Test Solution HT-2

Water	750cc
Kodak acetic acid, 28%	125cc
Kodak silver nitrate	7.5 g
Water to make	1 liter

The test solution should be stored in a stoppered bottle in darkness and must not come in contact with hands, clothing, or photographic material, because black stains would ultimately result.

To test for residual hypo in films, after washing, snip off a small piece from the clear edge of a film, and immerse it for about three minutes in a small amount of the test solution. Do not place a drop of the test solution on the margin of a wet film, because it may spread and stain the image. This technique, however, is very useful for testing dry films. Properly washed films will show only minimal or no discoloration.

To test for residual hypo in paper, after washing, wipe the surface water from the emulsion side of a print or from an unexposed test sheet of the same kind of paper that was processed as a control together with the prints. Place one drop of the test solution on the white margin of the print or on the face of the test sheet, allow it to stand for two minutes, then rinse it off. Compare the resulting stain with the Kodak Hypo Estimator, a card with color samples of stains indicating different percentages of residual hypo. It is available in most photo stores.

Test for residual hypo

Stock Solution

Distilled water	150cc
Potassium permanganate	0.3 g
Caustic soda	0.6 g
Distilled water to make	250cc

To test for residual hypo, add 1cc of the stock solution to 200cc of water. Remove one of the washed films or papers from the washing tank, and allow some of the water still adhering to it to drain into the test solution. Residual hypo will reveal its presence by changing the color of the test solution from purple to yellow.

Test for residual soluble silver salts. Away from sensitized material, prepare a 2% solution of sodium sulfide. Impregnate a strip of filter paper or white blotting paper with the test solution, then let it dry. To test for residual silver salts, allow a few drops from one of the washing films or papers to drain onto the test strip. Residual silver salts will reveal their presence by producing a yellow-brownish stain, indicative of the necessity for more thorough washing.

This test can also be used to determine the condition of the fixer: After washing has been completed, test for residual silver salts as described above. If the test is positive, continue washing for another half hour, then test again. If the test is still positive, the discoloration is probably due to an exhausted fixer, which was no longer able to convert unexposed silver halides into water-soluble compounds. In that case, the films or prints must be refixed in a freshly prepared fixer and subsequently washed again.

Kodak Hypo Eliminator HE-1. To achieve archival permanence, all traces of residual hypo must be removed from films and prints. This can be done with the aid of the following formula:

Water	500cc
Hydrogen peroxide (3% solution)	125cc
Ammonia solution (1 part concentrated 28% ammonia to 9 parts water)	100cc
Water to make	1 liter

This solution must be prepared immediately before use, kept in an open container during use, and discarded after use.

Wash prints for about half an hour in rapidly running water (or treat them with Kodak Hypo Clearing Agent in accordance with the accompanying instructions); then immerse each print for about six minutes at 68° F. in the hypo-eliminating solution. Subsequently, wash about ten minutes, then dry as usual. The capacity of this hypo eliminator is about 12 prints 8″ x 10″ per liter, or their equivalent (p. 130).

Kodak Gold Protective Solution GP-1. To achieve the highest possible degree of print permanence, the hypo-elimination treatment in HE-1 should be followed by a treatment in GP-1, which, by coating the silver image with a layer of gold, provides added protection against attacks by harmful gases of the atmosphere.

Water	750cc
Gold chloride, 1% stock solution	10cc
Sodium thiocyanate	10 g
Water to make	1 liter

To prepare the GP-1 solution, start by dissolving 1 g of gold chloride in 100cc of water. This will give you the 1% stock solution of gold chloride. Then add 10cc of this stock solution to 750cc of water.

Next, dissolve 10 g of sodium thiocyanate in 125cc of water; then add this solution slowly to the gold chloride solution while stirring rapidly. Finally, fill up with water to make one liter of working solution. The GP-1 solution should be prepared immediately before use.

For use, immerse the thoroughly washed prints, which previously should have been treated in Kodak Hypo Eliminator HE-1, in the gold protective solution for ten minutes at 68° F., or until a barely perceptible change in image tone from neutral black to blue-black takes place. Subsequently, wash for ten minutes, then dry as usual. The capacity of the GP-1 solution is approximately eight prints 8″ x 10″ per liter.

Developer stain remover for use on hands. Prepare a 1% solution of potassium permanganate and apply liberally to the hands until they are brown all over. Wash thoroughly with soap and water, then remove the brown stain by rinsing in a strong solution of sodium bisulfite.

Developer stain remover for use on clothes. Moisten the spot with a 5% solution of potassium permanganate, allow to soak for a few moments, and apply a 10% solution of sodium bisulfite to bleach out the stain. If colored fabrics are involved, it is advisable first to make a test on an inconspicuous part of the garment, since the treatment may affect the dye.

WEIGHTS AND MEASURES

Unfortunately, in this country, shortsightedness, misguided patriotism, and greed have prevented the official adaptation of the metric system of weights and measures, although it is used virtually everywhere else in the world, and in the United States in all fields of science. The result is a comic-opera kind of confusion where the number of different units of measure still in use make it all but impossible to convert weights or volumes given in one system to another. For example, in terms of the Avoirdupois system, there are ounces and there are fluid ounces; of these, the first equals 28.35 grams metric, while the second equals 29.57cc, although, in the metric system, grams, cubic centimeters, and milliliters are interchangeable. Furthermore, one ounce Avoirdupois equals 437.5 grains Avoirdupois, but one fluid ounce equals 8 drams fluid or 480 minims fluid. In addition to the Avoirdupois system, we also have the Troy system of weights and measures where one pound Troy equals 12 ounces (one pound Avoirdupois equals 16 ounces), one ounce equals 20 pennyweights, and one pennyweight equals 24 grains (which, of course, have nothing to do with the grains of the Avoirdupois system). And if we try to convert this nightmare into decimal measures, we end up with fractions that boggle the mind. Therefore, in this book, as a step in the right direction, I have given all weights and volumes in the metric form.

To convert from Avoirdupois to Metric, use the following tables. For example, one pound Avoirdupois equals 0.4536 kilogram; one kilogram equals 2.205 pounds Avoirdupois. And so forth.

Weight equivalents, Avoirdupois to Metric

Pounds	Ounces	Grains	Grams	Kilograms
1.0	16.0	7000.0	453.6	0.4536
0.0625	1.0	437.5	28.35	0.02835
		1.0	0.0648	
		15.43	1.0	0.001
2.205	35.27	15,430.0	1000.0	1.0

Liquid equivalents, U.S. to Metric

Gallons	Quarts	Ounces (fluid)	Drams (fluid)	Cubic centimeters	Liters
1.0	4.0	128.0	1024.0	3785.0	3.785
0.25	1.0	32.0	256.0	946.3	0.9463
		1.0	8.0	29.57	0.02957
		0.125	1.0	3.697	0.003697
			0.2705	1.0	0.001
0.2642	1.057	33.81	270.5	1000.0	1.0

If you wish to convert a formula given in Avoirdupois weights to the metric system (or vice versa), use the following conversion table:

Avoirdupois	=	Metric
Grains per 32 fl. oz. \times 0.06847	=	Grams per liter
Ounces per 32 fl. oz. \times 29.96	=	Grams per liter
Pounds per 32 fl. oz. \times 479.3	=	Grams per liter

Metric		=	Avoirdupois
Grams per liter	\times 14.60	=	Grains per 32 fl. oz.
Grams per liter	\times 0.03338	=	Ounces per 32 fl. oz.
Grams per liter	\times 0.002086	=	Pounds per 32 fl. oz.

To convert degrees Fahrenheit into degrees Centigrade, subtract 32, multiply by 5, and divide the result by 9.

To convert degrees Centigrade into degrees Fahrenheit, multiply by 9, divide by 5, and add 32 to the result.

To convert centimeters into inches, multiply by 0.3937.

To convert inches into centimeters, multiply by 2.54.

All of the titles on the next pages have been published in the United Kingdom by Thames & Hudson, London, *The Colour Photo Book* under the title *The Complete Colour Photographer* and *Total Picture Control* under the title *Manual of Advanced Photography*.

BIBLIOGRAPHY

If you liked this introduction to black-and-white darkroom techniques and wish to know more about related photographic subjects, you might be interested in the following books by this author:

The Complete Photographer (Prentice-Hall), 344 pages, including 32 pages of illustrations of which 16 are in color. This book offers a complete home study course in the skills, techniques, and art of photography and is divided into nine parts: the purpose of photography; the nature of photography; seeing in terms of photography; tools and materials; how to take a photograph; how to develop and print; the symbols of photography; scope and limitations of photography; and how to make good photographs.

The Color Photo Book (Prentice-Hall), 408 pages, 82 color photographs, 25 line drawings, 18 tables, 7 useful formulas. This book is devoted exclusively to color photography, covering every phase from the selection of the most suitable camera, lens, and film to discussions of some of the most advanced aspects of color photography. The book is divided into seven parts: introduction; equipment and material; how to take a picture; how to see in terms of photography; how to control the picture; how to enjoy your color shots; and random thoughts and observations.

Total Picture Control (Amphoto), 356 pages, including a picture section consisting of 271 pages (16 in color), which illustrates the different photographic controls—light, sharpness, contrast, color, glare, space, motion, and timing. The book is divided into five major parts: the purpose of photography; the extent of photographic control; control in regard to subject selection; control in regard to subject approach; and control in regard to subject rendition.

Basic Color Photography (Amphoto), 128 pages. A guide to color photography, illustrated with 98 photographs in color, 53 in black-and-white, 20 line drawings, and 5 tables. It probably is the most concentrated source of information on color photography of its kind.

Principles of Composition in Photography (Amphoto), 136 pages. An introduction to the purpose, nature, principle, elements and forms of photographic composition. 142 photographs in black and white, 8 in color.

Photographic Seeing (Prentice-Hall), 184 pages. A complete treatment of such vitally important photographic subjects as the characteristics of photography, photogenic and unphotogenic subject qualities and techniques, the different forms of seeing with emphasis on seeing in terms of photography, expressionistic seeing, and so on. 71 pages of illustrations, 16 of which are in color.

Books by other authors

Developing, by C. I. Jacobson (Amphoto), 391 pages. This is the best and most complete popular textbook on the subject of film development the author has found so far. Among others, it contains nearly 300 formulas and 50 comparative tables. It is recommended to anyone who wishes to go beyond the scope of *Darkroom Techniques.*

Lootens on Photographic Enlarging & Print Quality (Amphoto), 215 pages. This book is devoted exclusively to printmaking with special emphasis on those aspects dear to salon photographers and exhibitors. Although this author parts company with Lootens in regard to taste, he admires his thoroughness and his genuine feeling for print quality. The book is recommended as supplementary reading for those who wish to know more about the techniques of print toning, mounting, and retouching, which, for reasons of conviction, are treated only lightly or not at all in *Darkroom Techniques.*

And to those photographers who like to get the most value for their money, this author recommends the excellent Kodak publications, particularly the **Kodak Professional Data Books** and the **Kodak Information Books,** two series that are outstanding in every respect and, in my opinion, indispensable to anyone seriously interested in furthering his own photographic work, whether amateur or professional. At the insignificant price of from 95 cents to two dollars per book, they offer a fantastic wealth of authoritative information in concentrated form. I particularly recommend the following:

> *Kodak Professional Black-and-White Films* (F-5)
> *Kodak B/W Photographic Papers* (G-1)
> *Enlarging in Black-and-White and Color* (AG-16)
> *Professional Printing in Black-and-White* (G-5)
> *Processing Chemicals and Formulas* (J-1)
> *Kodak Color Data Guide* (R-19)
> *Kodak Master Darkroom Guide* (R-20)
> *Kodak Master Photoguide* (AR-21)

But, by all means, go to your photo store and look also at other Kodak publications. In my opinion, as far as straight technical information is concerned (unfortunately, the picture examples never rise above the snapshooter level), no other books provide so much solid substance for so little money.

Index